IMAGES
of America
ATWATER VILLAGE

August 11, 2011

To Bryan,

Happy Birthday !
Let this book inspire you to
become a great publisher some
day. Then you can put
your own name and picture
in your books as much as
you want. Best of luck.

John (a.k.a. Jan) Kinnon

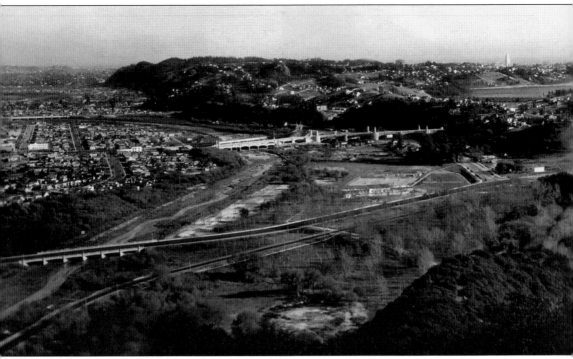

Taken around 1930, this aerial shows central and south Atwater Village alongside the natural Los Angeles riverbed with three newly constructed concrete river bridges: the Los Feliz Bridge, Glendale-Hyperion Viaduct, and Fletcher Drive Bridge. Above the Hyperion bridge is the Silver Lake Reservoir with Los Angeles City Hall in the background. Adjacent to Los Feliz Boulevard sits the Griffith Park Municipal Plunge and tennis courts. (Courtesy Glendale Public Library Special Collections.)

ON THE COVER: This photograph was taken looking northeast from the Hyperion Bridge across the dry Los Angeles riverbed (before embankment) around the 1940s. The Glendale-Hyperion Viaduct, also know as the Victory Memorial Bridge to honor World War I veterans, was built in 1928 and crosses over the Los Angeles River on to Glendale Boulevard through the heart of Atwater Village toward the City of Glendale. Visible on the hill to the right is the Forest Lawn sign. Also seen crossing the river on the far right is the Pacific Electric Railway Red Car entering Atwater Village. (Courtesy Los Angeles Public Library.)

IMAGES
of America

ATWATER VILLAGE

Netty Carr, Sandra Caravella,
Luis Lopez, Ann Lawson

Friends of Atwater Village

ARCADIA
PUBLISHING

Published by Arcadia Publishing
Charleston, South Carolina

Printed in the United States of America

Library of Congress Control Number: 2010941634

For all general information, please contact Arcadia Publishing:
Telephone 843-853-2070
Fax 843-853-0044
E-mail sales@arcadiapublishing.com
For customer service and orders:
Toll-Free 1-888-313-2665

Visit us on the Internet at www.arcadiapublishing.com

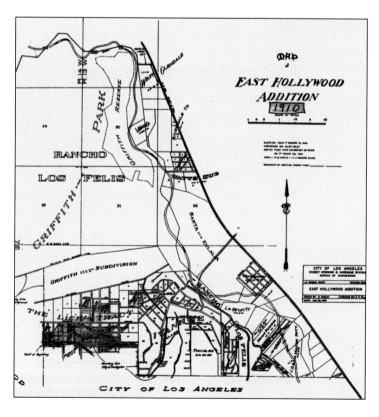

In 1910, the area shown on this map was officially annexed to the City of Los Angeles. Made by the City of Los Angeles Bureau of Engineering, it shows the East Hollywood Addition covering 7,112 acres or 11.11 miles. The election for annexation was held on February 18, 1910, and the notice was officially filed with the California Secretary of State on February 28, 1910. Atwater's outline is shown with the Southern Pacific right-of-way on its eastern border and the Los Angeles River as its western border. (Courtesy Los Angeles Public Library.)

CONTENTS

ACKNOWLEDGMENTS

While doing research for this book, we were fortunate to spend time with past and present residents of Atwater who share our enthusiasm for documenting the history of our neighborhood. They were generous in sharing their memories of growing up or working in Atwater, some from as early as the 1920s. Some left the area, while others have family ties that span five generations in the community. Their memories and the photographs we collected have given us an even greater appreciation for sharing and preserving our local history.

We wish to thank Cessiah Lane, a longtime resident who helped ignite our quest for Atwater Village history; Bette McMahon Hawkins and Jimmy Hawkins for their memories of life in Atwater from the 1930s to the present day; Mike Carone for sharing his childhood memories about the Los Angeles River; Ivan Forbes for details of his family's history in north Atwater; Buss Purcell for Van de Kamp's Bakery history; and Tom Overn and his long-lost friend Saburo Imahori, who were reunited through this book's research.

We also thank George Ellison, Glendale Public Library Special Collections; Terri Garst and Glen Creason, Los Angeles Public Library; Los Angeles City Councilmember Tom LaBonge; Mary Rodriquez, Los Angeles City Council District 4 Deputy; Ted Gaydowski, City of Los Angeles Records Management; Donald Seligman, Los Feliz Improvement Association; Danny Munoz and David Hiovitch Archives; Steve Crise, Pacific Electric Railway Historical Society; William Martin of Forest Lawn and Los Angeles river enthusiast; Joe Linton of www.lacreekfreak.wordpress.com; and Marie Conte and Darcy Kyburz for their invaluable expertise and support.

When we put out the call for old photographs of Atwater Village, several families took the time to dig through family albums and share their history. With our thanks, they are: Jan Kinnon, Joan Speed Pizzo, Larry Sepulveda, Nancy Franco, Larry Madrid, Betty Bartlotta, and Cynthia Brasington. Pastor Bruce Fleenor, Rev. Maurice Harrigan, Marie Delgado, Diana Van de Kamp, John Wickham of the Theodore Payne Foundation (theodorepayne.org), and Rex Link of the Los Angeles Breakfast Club provided photographs of churches, businesses, and organizations.

To everyone who was kind enough to fill out surveys detailing their memories or share a photograph of Atwater, please know that every detail helped enrich the story, and for this, you have our thanks.

A very special thank you to Lynn Wicklow Richardson, Bill and Susie Richardson, Gilbert and Kathy Richardson, and Paula Richardson Carroll, who generously gave their time to share the Richardson family history. Lynn, Bill, Gilbert, and Paula are great-grandchildren of W.C.B. Richardson.

INTRODUCTION

Atwater Village is a long, narrow section of northeast Los Angeles running alongside the Los Angeles River, situated in a verdant valley surrounded by the Verdugo, San Gabriel, and Santa Monica Mountains. It is 484 feet above sea level, 13 miles from the Pacific Ocean, and enjoys approximately 300 days of sunshine annually. Even in the warmest part of summer, residents enjoy a slight breeze blowing through. Atwater Village is a thriving community with a diverse population, and it has all of the amenities of a large city but retains the charm and quaintness of a village—all within the sprawling metropolis of Los Angeles.

Like most communities in the northeast part of the city of Los Angeles, Atwater Village was initially populated by the Tongva Native American tribes, who lived off the land in settlements along the Los Angeles River. After the Spaniards arrived in 1769 and land grants were given, the era of the ranchos began. The Atwater Village area was part of the original Rancho San Rafael land grant. In 1858, Catalina and Julio Verdugo gave attorney Joseph Brent the Santa Eulalia Rancho as payment for his legal services. The ranch changed hands several times before it was acquired by Samuel Heath, who sold it on August 14, 1868, to William Carr Belding Richardson, known as W.C.B. Richardson.

W.C.B. was a successful land surveyor who lived in Ohio with his wife and children. After hearing his brother Omar's glowing accounts of the weather and land investment opportunities in California, W.C.B. traveled by ship to San Francisco. From there, on horseback, he and his brother rode the length of the state looking for the best land to purchase. W.C.B. chose the 671-acre parcel of the Santa Eulalia Rancho, declaring it "the finest place in the state." W.C.B. was to become very instrumental in the growth and development of the area. He returned to Ohio and continued his business affairs. In 1871, he sent his son Elkanah to manage the ranch.

Under Elkanah, sheep ranching was the primary business until 1880, when W.C.B. returned to California with his wife, Sarah. They decided to replace sheep ranching with dairy and agricultural farming, taking advantage of the rich soil in the river valley. Fruit orchards were planted, and they started subdividing and irrigating the ranch to lease parcels of land to other farmers. Barley, vegetables, walnut groves, and grape vineyards were also planted and thrived. Father and son worked together managing the ranch for the next several decades.

The Southern Pacific Railroad began rapidly expanding its lines in Southern California, and in 1873, W.C.B. donated 16 acres of the Santa Eulalia Rancho for a rail stop that was named the Tropico Depot. Soon after, residents living close to the depot started referring to the surrounding area as Tropico. The name was further reinforced when the main east-west street through the area was designated Tropico Avenue (now Los Feliz Boulevard). By the 1880s, Tropico and Glendale had established separate identities and were recorded townsites within Los Angeles County. South Glendale and Atwater Village history are closely tied, as both were part of the Santa Eulalia Rancho and were later referred to as Tropico.

Always the ardent promoter of Tropico, W.C.B. gave land located west of the Southern Pacific tracks along Tropico Avenue to the Pacific Art Tile Company, founded in 1900 by Joseph Kirkham

and Col. Griffith Jenkins Griffith. From the onset, the factory employed a large number of people and further supported the development of the area. Sewer pipes, architectural terra-cotta, and ceramic tiles were produced at the factory.

Farming on the ranch was already in full swing around the beginning of the 20th century, when strawberries were planted in the fertile Tropico soil. Within a few years, the strawberry industry was booming, and it became a lucrative agricultural enterprise for the Santa Eulalia Rancho. The Brandywine variety called Tropico Beauties brought fame to the area, and Tropico would become the shipping center for strawberries grown in Glendale, Burbank, and Tropico. By 1903, several hundred acres of the ranch had been leased to Japanese farmers specifically for strawberry growing. Because of overproduction and the damaging frosts of 1907, many farmers withdrew from growing strawberries and switched to other crops. Gradually, farming land gave way to housing tracts.

L.C. Brand and Henry Huntington were instrumental in bringing the Interurban Pacific Electric Railway to the area, and W.C.B. Richardson donated land for the right-of-way through his Santa Eulalia Rancho, bringing the first local transportation. The big Red Trolleys started running in 1904. Traveling from downtown Los Angeles, they crossed the Los Angeles River, passing through strawberry and flower fields on today's Glendale Boulevard, heading to Glendale and beyond. The new trolley system made it possible for people to work downtown and commute to outlying areas. With transportation and jobs now accessible, residential development was the next step, and suburbanization was just around the corner.

Subdividing for housing in parts of the Santa Eulalia Rancho began around 1897. In 1902, forty acres near the Tropico Depot, close to where W.C.B. lived, were offered for sale to prospective homebuilders. It was appropriately named the Richardson Tract. The next subdivision stretched from the Southern Pacific tracks to the Los Angeles River and was named the Atwater Tract for its proximity to the Los Angeles River—"at water."

In 1908, W.C.B. Richardson, businessman and philanthropist, peacefully passed away at the age of 93 at his home in Tropico, leaving the ranch in the hands of his son Elkanah, who had managed it for the past 35 years. In his will, W.C.B. divided the Santa Eulalia Rancho in thirds, leaving it to his sons, Elkanah, Omar, and Bert. Eventually, all the sons would make Tropico and the Glendale area their home. Many of W.C.B.'s descendants still live in Southern California and have generously shared their family history with us.

When Glendale incorporated as a city in 1906, it became clear to Tropico residents that annexation to an incorporated city would secure the many improvements necessary for the future growth and development of the area. This prompted a Tropico annexation movement. Many residents of Tropico wanted to annex to the more developed city of Glendale, while others stood staunchly in opposition, wanting to remain Tropico; a third group wanted to annex to the city of Los Angeles. The southern portion of Tropico would be annexed to the city of Los Angeles in 1910 as part of the East Hollywood Addition, becoming today's Atwater Village.

The real estate boom in the Atwater Tract had begun. Early realtors and homebuilders bought parcels and subdivided and re-subdivided the land. In 1912, portions of the Richardson land closest to the railroad tracks on the Los Angeles side was platted into building lots measuring approximately 50-by-150-feet and ranging in price from $550 to $1,500. It was named the Angelus Tract. Improvements were immediately started on the newly subdivided acreage, with streets cut through the property, then graded, oiled, and tamped. Sidewalks and curbing were installed, and shade and ornamental trees were planted. The lower section was left unimproved due to the unpredictable flow and frequent flooding of the Los Angeles River. It was said that the area below Brunswick and Larga Avenues was often a swamp, and during a heavy rain season, the entire section would flood. After the 1914 Los Angeles River flood, berms were built to help control flooding. This prompted a second subdivision, with most building and home sales taking place between 1921 and 1922 predominately west of Brunswick and Larga Avenues.

Early wooden bridges over the Los Angeles River were often replaced due to damage caused by periodic massive flooding, and in the 1920s, wooden bridges that connected Atwater to Los

Feliz, Silver Lake, and Elysian Valley were replaced with concrete structures. The Tropico Bridge, later renamed the Los Feliz Boulevard Bridge, was built in 1924; the Fletcher Drive Bridge was built in 1927; and the most intricate bridge, the magnificent Hyperion-Glendale Viaduct, was completed in 1928. The Fletcher Drive and Glendale-Hyperion Bridges are both designated Los Angeles Historic Cultural Monuments.

In 1938, after 11 days of continuous rain, the banks of the Los Angeles River began to erode, giving way to another major flood. The concrete bridges stayed intact, but many people were killed and homes and buildings along the river were destroyed. The natural river's fate was sealed; it would be put into the cement straightjacket that we see today. After the Army Corps of Engineers realigned much of the river's course and built the concrete embankments, flooding was no longer a problem. Due to pressure from upwelling groundwater in the Atwater portion of the river, only the sides were armored, with no concrete poured in the riverbed. This remaining soft sandy bottom allows willow trees to thrive in the central sandbar islands, creating a habitat of greenery that attracts an abundance of local and migrating birds.

As Atwater continued to be developed, more businesses were started along its three east-west commercial corridors. In 1922, the Frank and Van de Kamp families opened a restaurant at Los Feliz Boulevard and Boyce Avenue, presently the Tam O'Shanter Inn. In 1930, the partners built a new bakery plant and moved their established Van de Kamp's Bakery business to Fletcher Drive from downtown Los Angeles. The Theodore Payne Nursery was also located on Los Feliz Boulevard next to the Gladding-McBean Pottery and Tile factory, which also produced Franciscan dishware. Today, Mortarless Masonry, a longtime local family business, carries vintage Gladding-McBean tiles that were used to adorn many fireplace surrounds in Atwater homes.

The Southern Pacific's Taylor Yard is less than a mile from Atwater. Many residents worked for the Southern Pacific as engineers, brakemen, switchmen, mechanics, and servicemen. Engineers that lived in Atwater gave a toot of the whistle to friends and family as they traveled past their homes. Today, the train toot is a familiar sound to all who reside in Atwater Village.

In addition to the larger companies that employed local residents, there were dozens of small independent businesses and many family-owned businesses that served the needs of the community. Vince's Market started in 1939, and Club Tee Gee was established in 1946; both are still thriving today alongside new independent businesses and specialty shops. It is fair to say that our working-class neighborhood is fortunate to have had these businesses that sustained themselves and employed many locals.

Atwater Village is also home to one of the few equestrian communities within the boundaries of the city of Los Angeles. Equestrians use approximately 55 miles of riding trails in Griffith Park, which is adjacent to Atwater Village.

Over the years, many artists have also called Atwater Village home. These include famed photographer Edward Weston, esteemed portrait artist Don Bachardy, and many other talented artists who live and work in our community today.

These days, Atwater Village is a vibrant, bustling community. The Los Angeles River still flows, but gone are the dairies, farmlands, and crops, replaced by homes, small businesses, and light industry. Our streets are lined with many of the original trees, keeping the ambiance of a small village and framing the wide variety of architectural styles of the homes and individualistic landscaping.

Welcome to Atwater Village!

Note: Initially called Atwater, the community officially became Atwater Village in 1986 and this book uses both references.

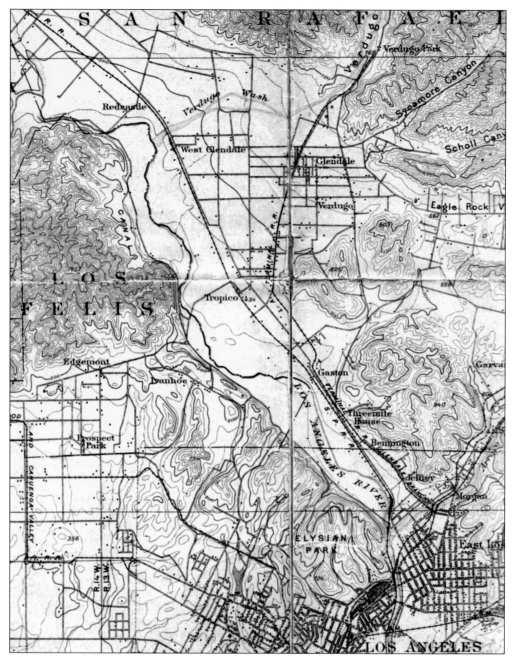

This 1908 Los Angeles County topographical map shows a very populated Los Angeles near the downtown area. The rest is mostly open space. Shown next to the Los Feliz area is Tropico (originally the Santa Eulalia Rancho), alongside the Los Angeles River. In 1910, the southern portion of Tropico would annex to the city of Los Angeles, and the northern portion of Tropico east of the railroad tracks would become part of the city of Glendale. (Courtesy Los Angeles Public Library.)

One

SANTA EULALIA RANCH TO TROPICO TO ATWATER VILLAGE

William Carr Belding (W.C.B.) Richardson was a pioneer settler, proprietor of the Santa Eulalia Rancho, and first citizen of Tropico. Born in 1815 in Swanzey, New Hampshire, he was raised in Ohio, and like his father, he became a land surveyor. He married Sarah Everett, and they raised their family in the Cleveland area. W.C.B. was a businessman who met with eminent success and acquired wealth and distinction. Because of his civic-minded generosity, he was instrumental in the development of Tropico, the community he had envisioned. (Courtesy Glendale Library Special Collections.)

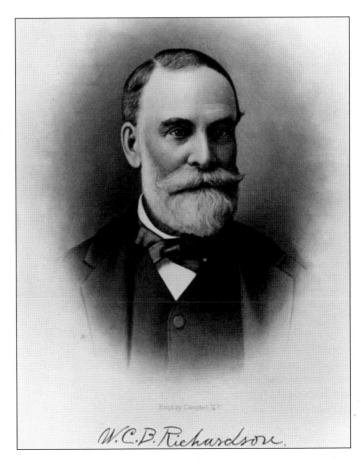

W.C.B. Richardson.

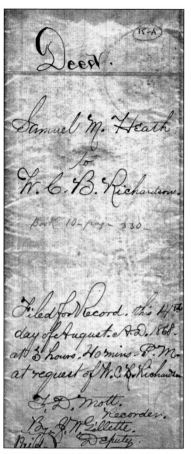

Pictured is the front cover of the deed for the sale of the Santa Eulalia Rancho. The rancho had been a part of the original San Rafael land grant owned by the Verdugo family. Joseph Lancaster Brent acquired the land from Catalina and Julio Verdugo, then the parcel changed hands again, becoming the property of Samuel M. Heath, who sold it to W.C.B. Richardson in 1868. (Courtesy Gilbert Richardson; John Richardson Collection.)

An 1880s aerial view shows the verdant Los Angeles River valley lying between the Verdugo Mountains and the hills of today's Griffith Park, looking to what would later become Atwater Village. Early division of the land into parcels for farming and an orchard can be seen. (Courtesy Los Angeles Public Library.)

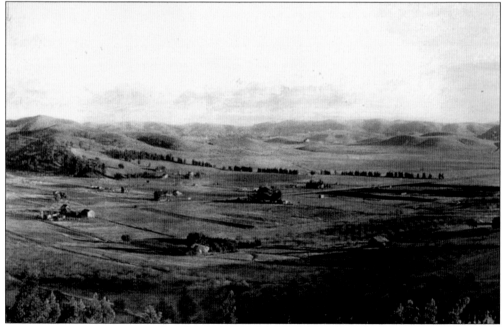

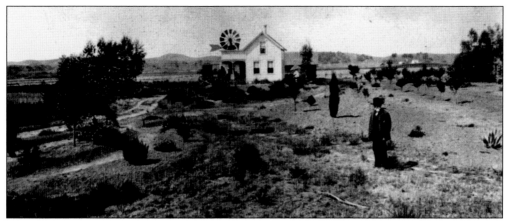

W.C.B. Richardson is seen in front of his original farmhouse, built in 1873 on the Santa Eulalia Rancho. The rancho included all of present-day south Glendale and the Atwater District of Los Angeles. The house has historic status as the oldest redwood frame house in Glendale. When the property was subdivided, it was moved to the corner of Mariposa Street and Cypress Avenue in Glendale. (Courtesy Los Angeles Public Library.)

1881	Richardson Diary	1881	BMV

June 6	Wrote to Capt. Pedrick, Cleveland, Ohio, to sell or trade the land for $1.00 per acre.
June 7	Hoeing corn.
June 8	Went to town.
June 9	Commenced the new allotment of the ranch.
June 10	We worked in the orchard. Wrote to Celest.
June 11	Setting the south line.
June 12	Sunday.
June 13	Subdividing the rancho.
June 14	We were working at the subdivision of the rancho.
June 15	We went to the city. Checked out 10 dollars.
June 16	Surveying and irrigating Mr. Emery's place adjoining our ranch. Has just sold for 60 dollars per acre.
June 17	Surveying on the river.
June 18	Surveying.
June 19	Sunday.
June 20	Surveying on the rancho.
June 21	Set 12 stone monuments on the corners of the farms.
June 22	We went to the city. Checked out 10 dollars. Got a letter from Capt. Pedrick wanting the abstract of the Kentucky land.
June 23	Staking the lots east of the railroad. Saw the man that bought Mr. Emery's place. He says he will wtite to his friend at San Francisco to buy some of these lots.
June 24	Miss Levering's school picnick in the Verdugo Canyon.

This excerpt from W.C.B.'s diary in June 1881 documents daily life on the rancho. W.C.B. kept a diary, making daily entries from 1850 to just before his death in 1908 at the age of 93, showing a remarkable example of an industrious, methodical, and well-regulated life. W.C.B.'s daughter-in-law Ella Richardson had the original diary transcribed through a Works Progress Administration program in 1939. (Courtesy Gilbert Richardson; John Richardson Collection.)

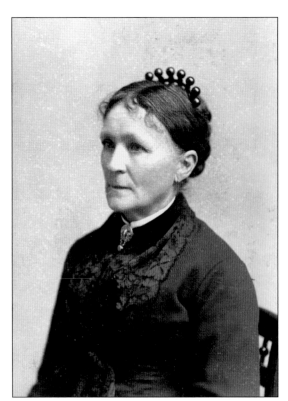

Sarah Everett married W.C.B. Richardson in Ohio on October 28, 1838. They were married for 57 years and raised four children: Omar Sebastian, Elkanah Wyman, Mary Ella, and Albert William. Sarah died on the Santa Eulalia Rancho in 1895 at the age of 73. (Courtesy Gilbert Richardson; John Richardson Collection.)

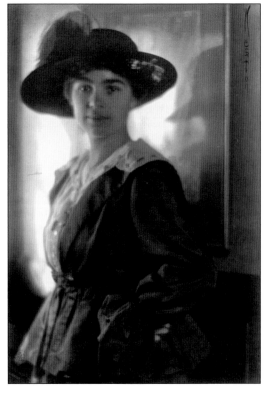

This Edward Weston photograph is of Eulalia Richardson, the daughter and first child of Elkanah and Ella Richardson. She was born on the Santa Eulalia Rancho on November 2, 1888, and was named after her birthplace. Eulalia graduated from Stanford University in 1913. Today, there remains a street near Forest Lawn in the city of Glendale named Eulalia Street. (Courtesy Paula Richardson Carroll and the Huntington Art Collection, San Marino, California.)

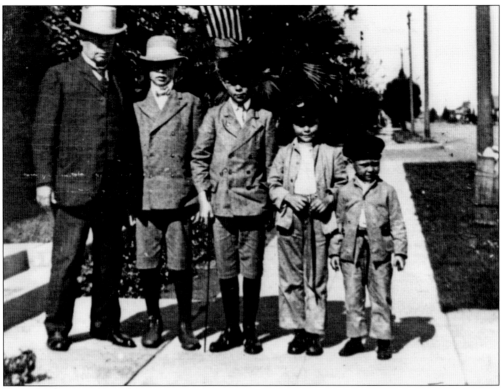

On July 4, 1908, Elkanah Wyman, son of W.C.B., poses with his four sons. Standing, from left to right, are sons Elkanah William; Omar Burt; Paul Eddy, and John Henry. All the boys were born and raised on the Santa Eulalia Rancho. Elkanah was one of the organizers and incorporators of Tropico. (Courtesy Gilbert Richardson; John Richardson Collection.)

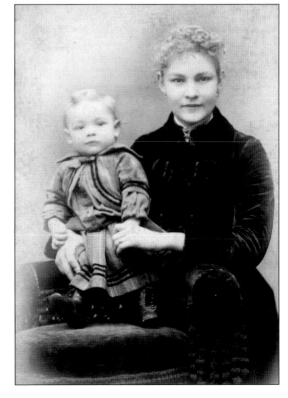

Ella Weekley was born in Pontiac, Michigan, on June 3, 1870. She married Elkanah Wyman Richardson in 1887 and is shown here with their first son, Elkanah William. After the death of her husband, Ella continued to be a supporter of Tropico, and for a short time in 1914, she owned the *Tropico Sentinel* newspaper. Her later years were devoted to various civic organizations. (Courtesy Gilbert Richardson; John Richardson Collection.)

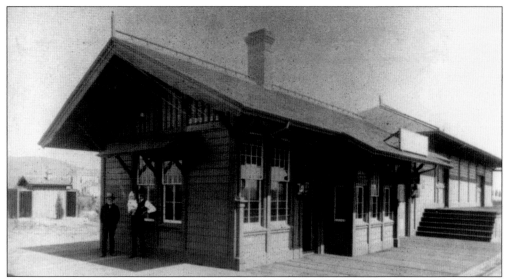

W.C.B. Richardson is standing on the left with the stationmaster at the Tropico Depot around 1907. W.C.B. donated the land for the depot to the Southern Pacific Railroad on March 11, 1873, but the depot was not built until 1877. The railroad company named the depot, but W.C.B. and his son Elkanah, along with local residents, formed the townsite of Tropico. (Courtesy Gilbert Richardson; John Richardson Collection.)

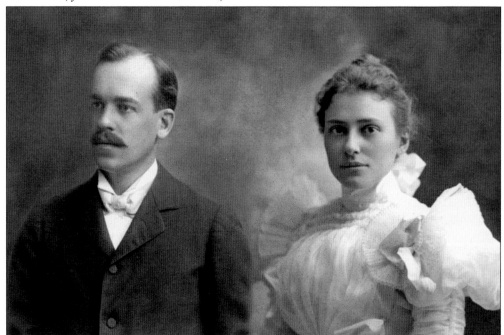

W.C.B. Richardson II, the eldest son of Omar Sebastian Richardson and grandson of W.C.B. Richardson, is pictured with his wife, Clara Zeese, in the early 1900s. W.C.B. II and Clara made their home at 3519 Atwater Avenue. W.C.B. II was instrumental in the building of the first bridge across the Los Angeles River on Tropico Avenue (now Los Feliz Boulevard). He convinced his grandfather that the bridge would afford a shorter route to the beach than the longer route via downtown Los Angeles. (Courtesy Bill and Susie Richardson.)

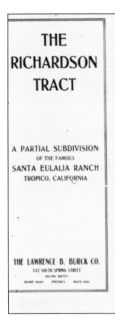

The river and the newly constructed Pacific Electric Trolley Line are detailed in this brochure advertising the first subdivision of Santa Eulalia Rancho, Tropico, California. The subdivision was located in today's south Glendale near the Tropico Depot, east of the Southern Pacific tracks. West of the railroad tracks were the more sparsely populated farmlands of the rancho. A selling point of the subdivision was its close proximity to the more developed downtown Los Angeles. (Courtesy Gilbert Richardson; John Richardson Collection.)

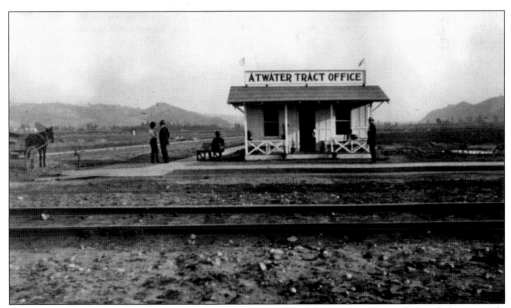

Around 1905, the Atwater Tract Office, located on Glendale Boulevard, sits behind the recently laid Pacific Electric Railway tracks. The tract is Santa Eulalia Rancho's second subdivision, and the real estate men are dressed for business. A horse-drawn buckboard is parked at the left of the office, possibly to transport perspective buyers. This photograph was in W.C.B. Richardson's family photo album. (Courtesy Lynn Wicklow Richardson and Glendale Public Library Special Collections.)

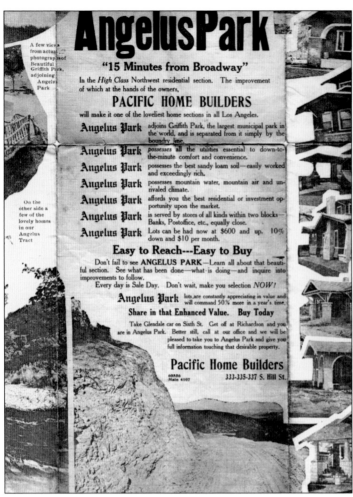

Pacific Home Builders, the largest owners of home-building property in Los Angeles at the time, owned the Angelus Park development. This section included the area from Seneca Avenue to Brunswick Avenue along Tropico Avenue (Los Feliz Boulevard) to Glendale Boulevard. The lots were sold by the realty agency of Rigali and Veselich. Rigali Avenue and Veselich Avenue in north Atwater are named for these realtors. (Courtesy Bill and Susie Richardson.)

Alexander Omar Richardson, son of W.C.B. II, built this house for himself in 1922 on Revere Avenue. Today, many homes of a similar style can be seen on Revere Avenue. (Courtesy Bill and Susie Richardson.)

ATWATER TRACT
Formal Opening, Next Sunday

15 Minutes—Lots $625—Terms

—Atwater Tract, fifteen minutes from Broadway, in the city limits with city conveniences and improvements, will be formally opened Sunday, November 24. Come out and select YOUR lot NOW.

—We want you to see this—the cream, the very best of all subdivision buys for the home builder—now that a number of handsome homes are being built here.

—Ideal location, fine soil, on a high dry mesa, with an ever-changing vista of beautiful mountains almost surrounding make this tract simply ideal. There is NOTHING in any direction at twice the price that can TOUCH Atwater Tract.

—Large lots at $625.00 and up on the easiest of terms. Can you match this offer anywhere else—in or out of the city? Can you get a lot as accessible with similar improvements in or out of the city? Just try it.

—Don't think that you MUST go in any certain direction for a homesite—there are beautiful homes—hundreds of them out this way and hundreds more being built—and all this development in the past few weeks.

—Hillhurst Park, Griffith Park, Los Feliz Boulevard, Angelus Park—all are NEAR Atwater Tract—come to our office today for complimentary tickets. If you prefer, take a Glendale car on Sixth Street—get off at Atwater Avenue, 3 miles THIS SIDE OF GLENDALE. Tract office and courteous salesmen right there all day—every day.

—$50.00 DOWN—

—fifteen minutes from the city's center, Sixth and Broadway.
—city conveniences, city gas at city rates. City specification streets, cement walks, curbs and cement gutters. Electricity, telephones, water now piped to every lot. Trees and parkings—all these improvements in and PAID FOR. Many more coming—and these are the prices.
—$625 to $1200.
—$50 to $100 cash down.
—$6 to $20 monthly payments.
—Prices include improvements.
—Payments include principal, interest and taxes at option of purchaser.
—Ample restrictions.

—HOMES—

We will build you a home to order for 10 per cent down and payments, 1 per cent monthly, including principal and interest, in beautiful Atwater Tract. Seven handsome homes now building and many more being planned for immediate construction. Come in and see us—bring your plans or let us draw them for you.

BUMILLER & RIDENBAUGH

F1938 418 to 423 Consolidated Realty Building Main 3511

One of the earliest tracts offered for sale in Atwater Village, this advertisement from the November 17, 1912, *Los Angeles Times* states that the formal opening for the Atwater tract was on Sunday, November 24. The advertisement touts the convenience of being only 15 minutes from Broadway in downtown Los Angeles. It also states, "Ideal location, fine soil on a high dry mesa, with an ever changing vista of beautiful mountains . . . simply ideal." (Courtesy Los Angeles Public Library.)

19

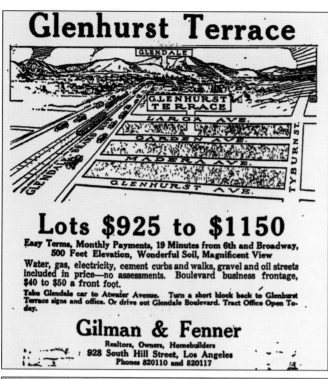

Glenhurst Terrace

Lots $925 to $1150

Easy Terms, Monthly Payments, 19 Minutes from 6th and Broadway, 500 Feet Elevation, Wonderful Soil, Magnificent View

Water, gas, electricity, cement curbs and walks, gravel and oil streets included in price—no assessments. Boulevard business frontage, $40 to $50 a front foot.

Take Glendale car to Atwater Avenue. Turn a short block back to Glenhurst Terrace signs and office. Or drive out Glendale Boulevard. Tract Office Open Today.

Gilman & Fenner
Realtors, Owners, Homebuilders
928 South Hill Street, Los Angeles
Phones 820110 and 820117

From 1921 to 1922, the remaining sections of Atwater were developed. In this advertisement from the *Los Angeles Times* dated 1921, the section south of Glendale Boulevard to Tyburn Street is being offered for sale. It describes "wonderful soil and magnificent views" as reasons to buy. Directions to the sales office are "take the Glendale car to Atwater Avenue. Turn a short block back to the Glenhurst Terrance signs and office." (Courtesy Los Angeles Pubic Library.)

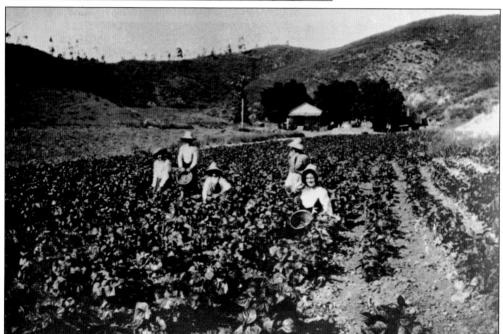

Around 1900, Japanese farmers dressed with hats and long sleeves work the strawberry fields of Tropico with baskets in their hands, likely ready to pick. Strawberries were a major industry for Tropico, and by 1903, several hundred acres of land were leased to Japanese farmers for strawberry growing. The boom lasted until about 1908, and shortly thereafter, housing tracts replaced the strawberry fields. (Courtesy Forest Lawn Memorial Park.)

Two

DOWN BY THE RIVER
AND OVER ITS BRIDGES

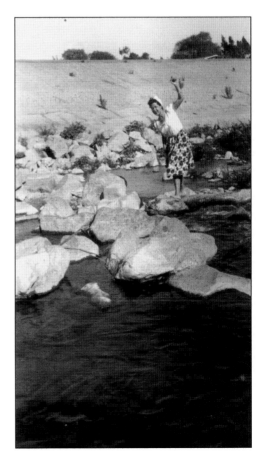

The Los Angeles River is the water in "Atwater." Its bridges are among the most prominent and recognizable architecture in the community. The river was described in the earliest written account of the area in 1769. The Portolá expedition's Father Crespi described the natural river as a "good-sized full flowing river . . . with very good water, pure and fresh . . . very lush and pleasing . . . in every respect." This 1942 photograph shows Atwater resident Esther de Heras Brasington enjoying time at the river. Children growing up in Atwater have fond memories of catching pollywogs and watching them change into frogs. (Courtesy Brasington family.)

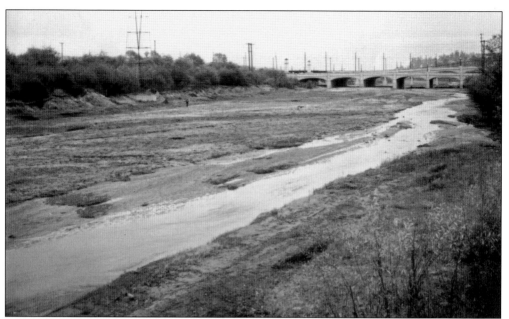

In the 1930s, it is a dry season and the Los Angeles River is only a trickle as a pedestrian walks across the natural earthen riverbed. The river was an important resource for Native Americans and early agricultural settlers. Due to flooding, most of the river was armored with concrete except in the Glendale Narrows stretch, including Atwater Village. The bottom of the river was not concreted and remains relatively natural. (Courtesy Los Angeles City Archives.)

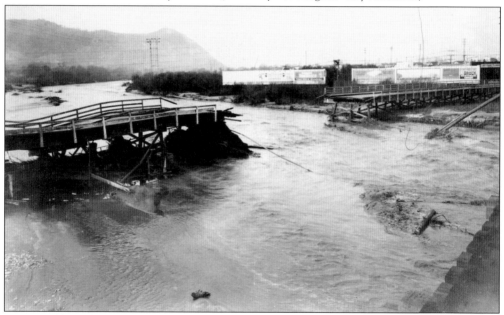

During the early history of Los Angeles, the river flooded every couple of years. Major floods were recorded in 1862, 1867–1868, 1884, and 1889, with lesser flooding common in other years. This undated photograph, likely from the 1920s, was taken from the Pacific Electric Railway line (tracks visible at bottom right) looking upstream at a flood-damaged wooden bridge at the site of today's Glendale-Hyperion Bridge. (Courtesy Los Angeles City Archives.)

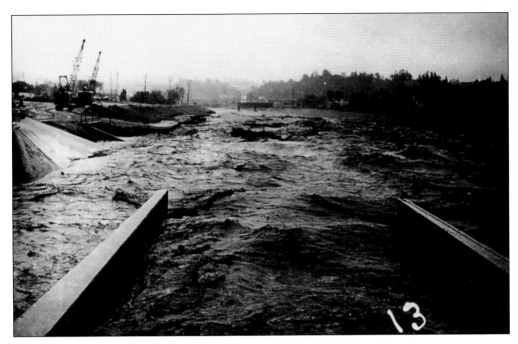

Two undated images show the Los Feliz Boulevard Bridge and the waters of the Los Angeles River at flood stage. The Los Feliz Bridge, originally known as the Tropico Bridge, opened in 1925. The image below was taken from the downstream sidewalk of the bridge facing northeast. Both images show the bridge's elongated pier walls designed to help streamline water flow beneath the bridge. (Both, courtesy Los Angeles City Archives.)

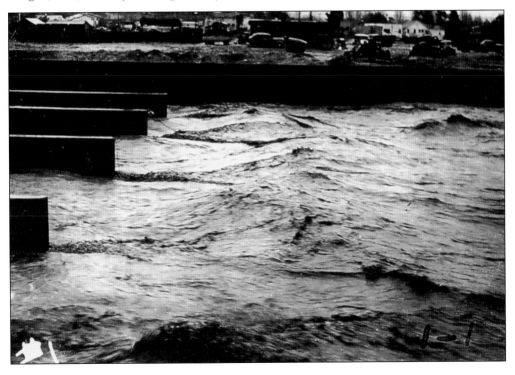

The iconic Glendale-Hyperion Bridge opened in 1929. The complex 1,152-foot-long multispan bridge was the first million-dollar Los Angeles city bridge project. It was named the Victory Memorial Viaduct, honoring World War I veterans. Merrill Butler was the city bridge engineer from 1924 to 1961 who is generally credited for overseeing the design and construction of the city's now-historic bridges. He called this "an architectural jewel in a landscaped setting." (Courtesy Los Angeles City Archives.)

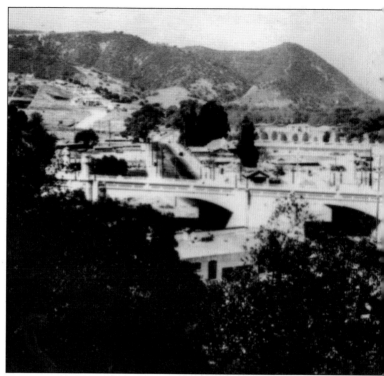

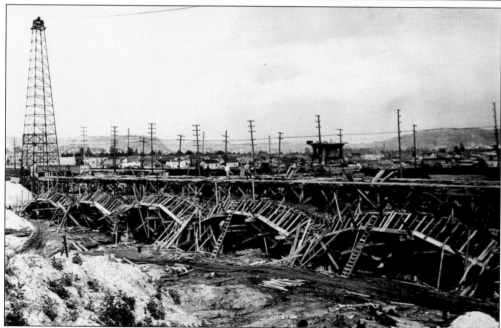

In 1924, the City of Los Angeles passed a $2-million Viaduct Bond Act, which provided the resources to modernize and build bridges. This 1920s photograph shows the extensive wooden falsework built to form the multiple concrete arches of the Glendale-Hyperion Bridge. The picture was taken from the west bank of the river looking east downstream, with Atwater Village homes visible in the background. (Courtesy Los Angeles City Archives.)

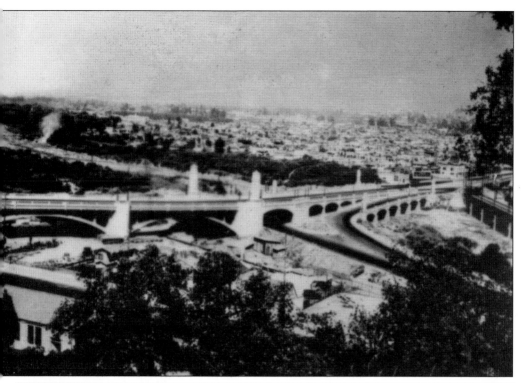

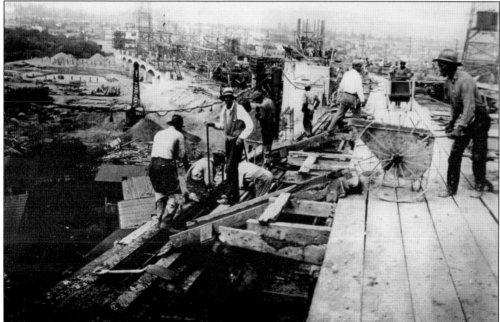

Prior to the city's ambitious bridge-building programs of the 1920s and 1930s, wooden bridges spanned the river. Wooden bridges often suffered flood damage and required a great deal of maintenance. This 1927 photograph shows the complex construction of the Glendale-Hyperion Bridge. This photograph was taken looking easterly across the Los Angeles River and on into Atwater. (Courtesy Los Angles City Archives.)

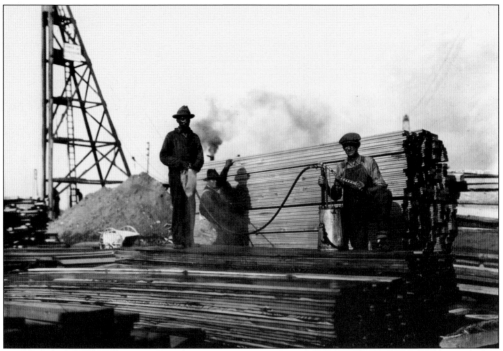

Though Atwater Village bridge construction was complete before the 1930s federal public works job-creation initiatives, 1920s bridge building was nonetheless labor-intensive. Mobilization and construction spanned years and provided jobs for skilled and unskilled laborers. This 1920s photograph shows workers building the Glendale-Hyperion Viaduct. (Courtesy Los Angeles City Archives.)

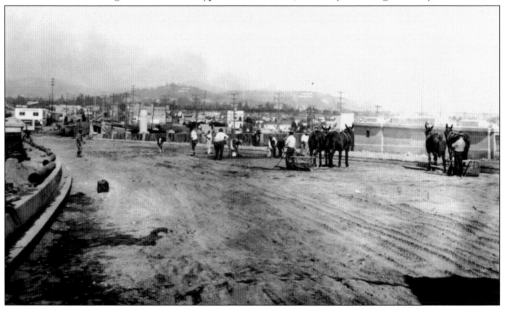

Early-20th-century bridge construction still relied on mule teams for many tasks requiring heavy pulling. This 1920s photograph shows mule teams helping grade the Glendale-Hyperion Bridge deck roadway surface. Visible in the background is Atwater Village's Glendale Boulevard commercial district. (Courtesy Los Angeles City Archives.)

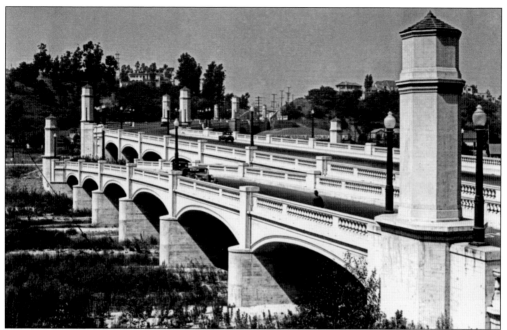

This is how the Glendale-Hyperion Bridge looked when completed in 1929. Note the ornamental concrete railings and octagonal pylons. A pedestrian is walking over the Glendale Boulevard Bridge alongside a 1930s car. Going up the Hyperion Avenue Bridge is a 1920s Model T. The river below is very dry with natural scrub. The photograph was taken from the Pacific Electric Railway track. (Courtesy Department of Water and Power.)

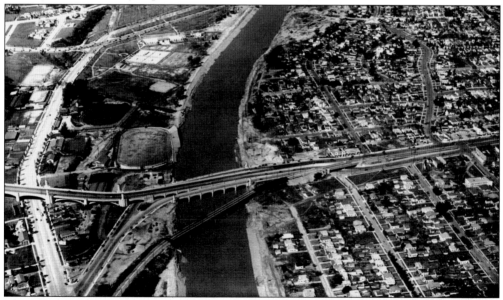

This aerial shows the river between Los Feliz Boulevard and Glendale Boulevard soon after the devastating flood of March 1938. On the left, from bottom to top, are the Hyperion Bridge, horse stables, the flood-damaged Victor McLaglen Stadium, the Los Angeles Breakfast Club, a baseball diamond, tennis courts, and the municipal plunge. Riverside Drive is on the left, parallel to the river. Note the Pacific Electric Red Car crossing the river. (Courtesy Los Angeles City Archives.)

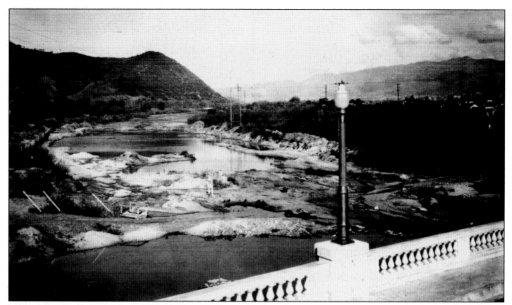

The photograph above, taken looking upstream from the newly constructed Glendale-Hyperion Bridge, shows the relatively natural, untamed Los Angeles River bed. Mike Carone, pictured below at the Sunnynook Footbridge, moved to Atwater Village in 1928. He recalls spending his childhood in and around the then-natural river. Prior to the floods of 1934 and 1938, Carone recalls playing in "the fresh water swimming hole next to the street car trestle," catching steelhead and crawdads, shooting rabbits, picking plums from an adjacent orchard, and drinking milk from the Crosetti family's cows that pastured along the river. "Today," Carone laments, "it is no place for kids to enjoy what Mother Nature gave me when I was a kid." The Sunnynook Bridge was built in 1932 at a cost of $5,000; it measures 250 feet long and 6 feet wide. (Above, courtesy Los Angeles City Archives; below, courtesy Netty Carr.)

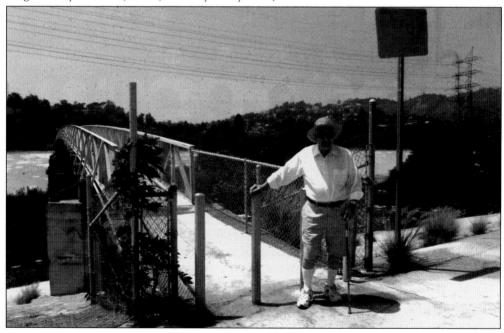

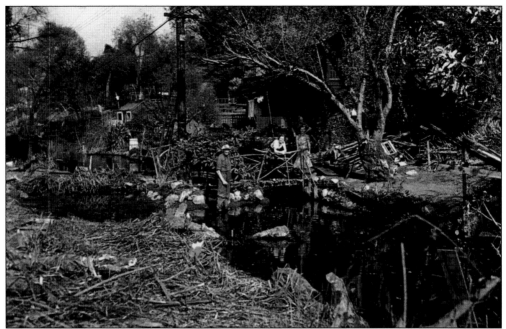

Legion Lane and the Los Angeles River are pictured in the 1930s, prior to concrete channelization. During heavy rainfall years, the river would overflow, and this stretch became an unofficial local swimming hole. The photograph shows the backyard of the home at 3812 Valleybrink Road. (Courtesy Cessiah Vasquez Lane.)

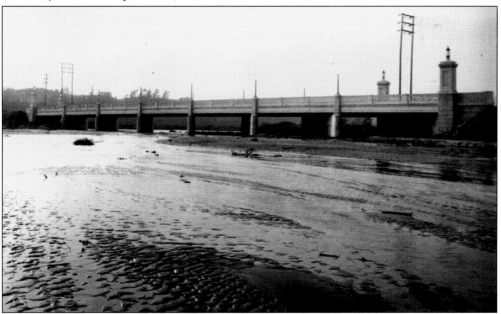

The Fletcher Drive Bridge was completed in 1927. The city's bridge program was part of a broader "City Beautiful" movement, which sought to create monumental public architecture to uplift the lives of city dwellers. Though all of the bridges show a similar character, they each have their own unique features. Fletcher features stately large rectangular pylons supporting ornamental lanterns. (Courtesy Los Angeles City Archives.)

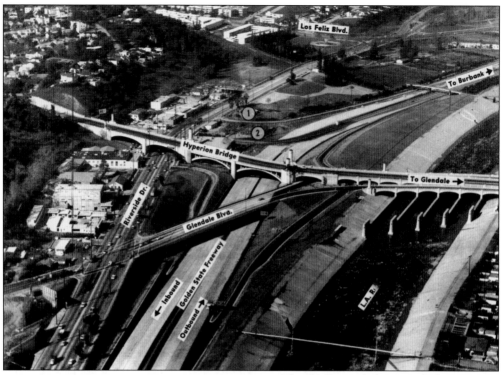

Los Feliz Blvd.

To Burbank →

Hyperion Bridge

To Glendale →

Riverside Dr.

Glendale Blvd.

Golden State Freeway

Inbound

Outbound

L.A.R.

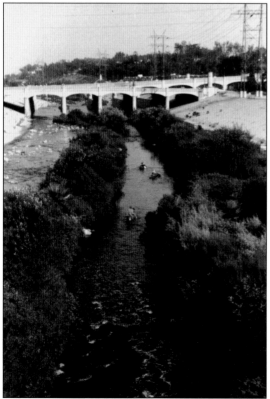

This 1962 aerial photograph diagrams the configuration of the Golden State Freeway while under construction. The Interstate 5 Freeway severed Griffith Park's connection with the river. Atwater Village homes are visible in the bottom right, next to the newly concrete-walled river. The Pacific Electric Railway tracks are gone, though its pier walls remain downstream from the Glendale-Hyperion Bridge. (Courtesy Los Angeles Public Library.)

This 1990s photograph shows three boats navigating the river upstream of the Glendale-Hyperion Bridge. Between sloped concrete banks, vegetation has reclaimed the earthen bed of the river. Atwater's riverbed has tall willow trees, abundant bird life, and fish. Atwater Village residents walk, run, bike, and fish there. Since the mid-1980s, community groups, starting with Friends of the Los Angeles River, campaigned for the river's revitalization. (Courtesy Los Angeles Public Library.)

Three

TRAINS AND TROLLEYS

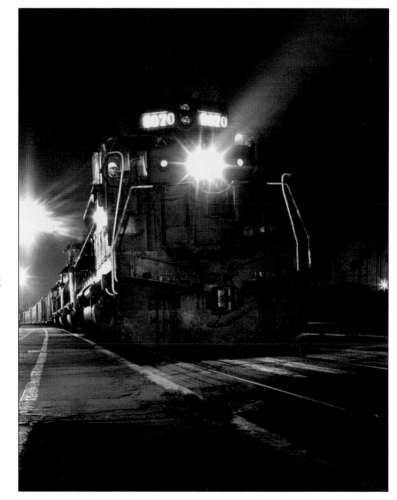

A Southern Pacific freight train pauses at the Glendale Station as a "helper" locomotive is attached to the rear of this perishables express train. St. Louis and Southwestern Railway locomotive No. 8970 is a Special Duty 45 model built by the Electro-Motive Division of General Motors in 1965. Engineer W.E. McKim was at the control of this train in April 1976. The palm trees visible on the right-hand side are along Seneca Avenue in Atwater Village. (Image by Steve Crise.)

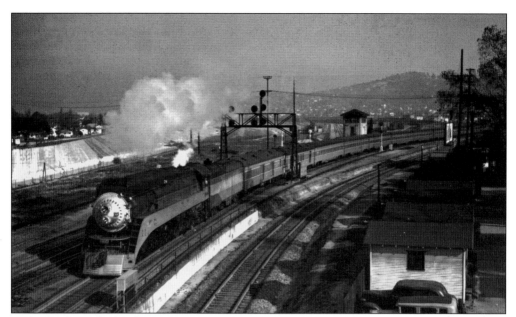

Taylor Yard was the local maintenance yard for the Southern Pacific. Many residents of Atwater were employed at the yard, which was less than a half-mile from Atwater's border. Engineers George Longo and Hoot Mayo were local Atwater residents who would give a blast of the horn as their trains sped past Fletcher Drive, Silver Lake Boulevard, and Tyburn Avenue. The steam engine in this photograph was a Lark all-sleeper passenger train that ran on the route from San Francisco to Oakland to Los Angeles. (Courtesy Pacific Electric Railway Historical Society; image by Donald Duke.)

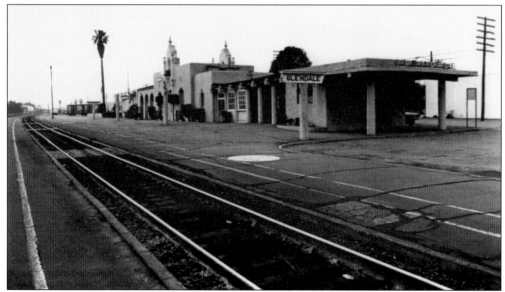

The backside of the current City of Glendale Transportation Depot at 400 Cerritos Avenue is shown. The Spanish Mission Revival–style depot was built in 1923 to replace the original 1883 Tropico Depot. Today, it is a busy transportation hub with Amtrak, Metrolink, and Greyhound service. Central Atwater Village residents can see the arched entryway from their homes and hear the daily train whistle. (Courtesy Los Angeles Library; image by Tom La Bonge.)

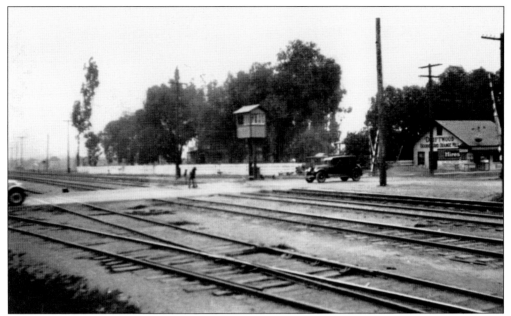

This photograph shows the Southern Pacific tracks at Los Feliz Boulevard in the 1920s. Shown is a wooden tower where "tower men" sat and pulled the switches to lower the wooden crossing gates that held back motorists. The Los Feliz underpass was built in the late 1950s to accommodate the ever-expanding use of automobiles. On the right is a market advertising the sale of Hires Root Beer. (Courtesy Glendale Public Library Special Collections.)

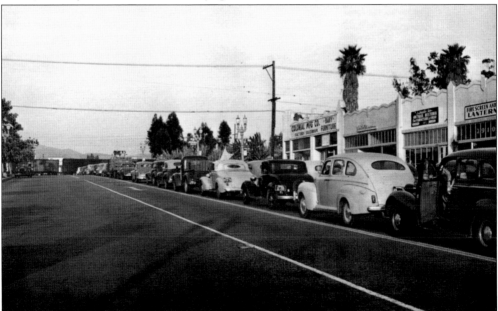

Traffic backs up in the 1930s along Los Feliz Boulevard at Seneca Avenue. The cars and drivers are seen waiting for the train to go by. The Southern Pacific railroad tracks cross Los Feliz Boulevard, causing a backup every time a long freight train passed through. The Sea and Jungle Shop at 2858 Los Feliz is gone, but the original building at 2904 remains and houses Quick Frames. (Courtesy Glendale Library Special Collections.)

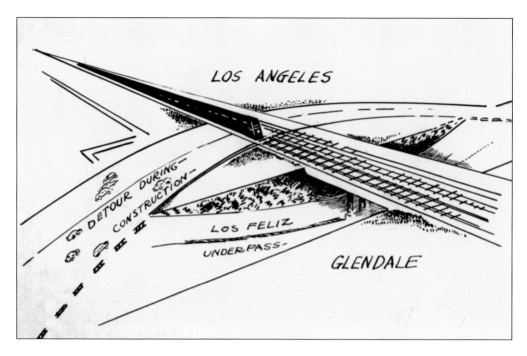

The railroad crossings from Atwater into Glendale and back became so congested that, in the early 1950s, it was proposed that underpasses be built to alleviate the long wait times as shown by this 1954 drawing. Los Feliz Boulevard was chosen to be the first, and grading was started in 1956. The Glendale Boulevard underpass was constructed next. In the photograph below, some construction is still being done on the north bank. The third and last underpass in Atwater was on Fletcher Drive in the 1960s. (Courtesy Glendale Public Library Special Collections.)

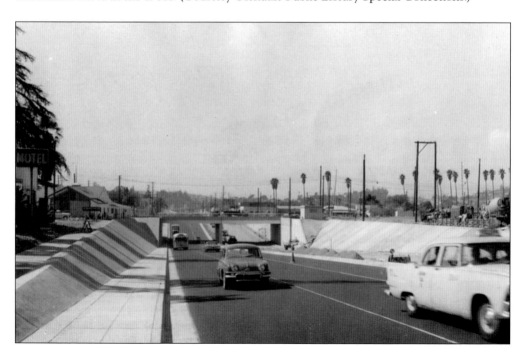

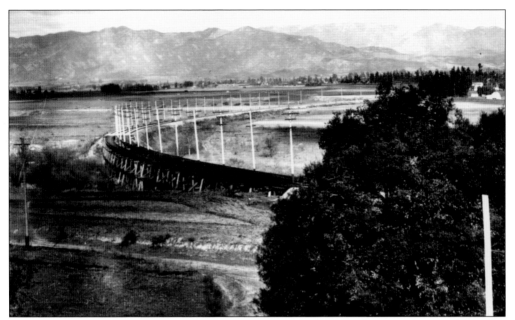

Looking at open landscape along the Pacific Electric Railway tracks around 1904, the trolley coming from the Monte Sano stop in Silver Lake traverses over the Los Angeles River and passes through the farms of Santa Eulalia Rancho on the way to Glendale. Within a decade of the Pacific Electric Railway's arrival, the ranch would be divided up and sold to developers for housing tracts. (Courtesy Los Angeles Public Library.)

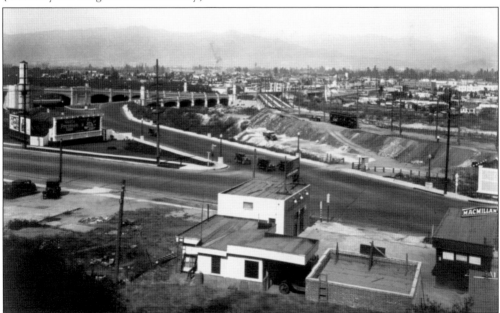

This view is looking along the Hyperion Bridge with the Pacific Electric Railway crossing into Atwater. Model Ts stop at the intersection of Riverside Drive and Glendale Boulevard in front of the River Glen Café on their way to Silver Lake. The Pacific Electric Red Car is going over the dry Los Angeles River bed while workers are seen near the track. Beach's Market is visible in the already developed central and south Atwater. (Courtesy Los Angeles Public Library.)

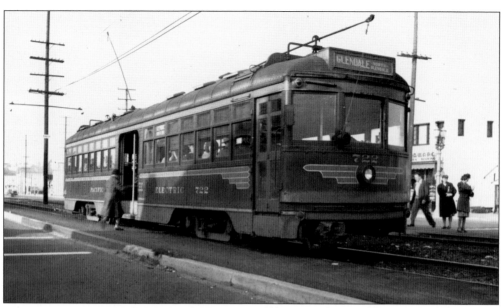

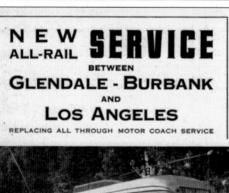

This 1947 photograph shows Pacific Electric Railway Hollywood Car No. 722 outbound to Glendale on Glendale Boulevard in Atwater. Passengers headed to Glendale can be seen boarding the train from both sides of the track. The building occupied by the hardware store in the picture is still standing today at the corner of Seneca Avenue. (Courtesy George Ellison Collection; image by Tom Gray.)

This front cover of a 1940 schedule for the Pacific Electric Railway boasts 10 new PCCs (Presidential Coach Cars) "to meet every travel need between the hearts of Glendale-Burbank and Los Angeles." Inside, the schedule shows the first Red Car of the day arriving at the Richardson Stop (Seneca and LaClede Avenues) at 4:16 a.m. (Courtesy George Ellison Collection.)

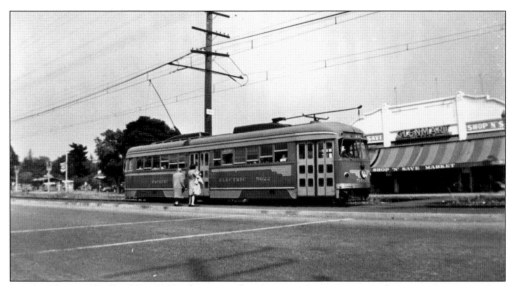

Pacific Electric Trolley No. 5022, shown at the Atwater Avenue stop, takes on more passengers on its way to downtown Los Angeles. The Glenmart advertises for shoppers to "Stop 'n' Save" in this photograph from the late 1940s or early 1950s. The last Red Car ran on this line in 1955, and the tracks were dismantled soon after. (Courtesy Sandra Caravella.)

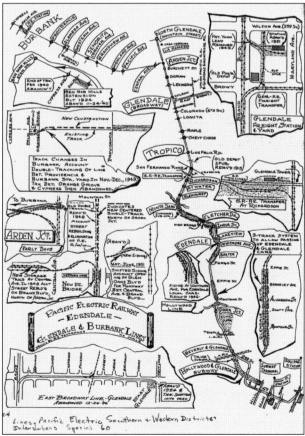

This 1950s map of the Pacific Electric Railway's Edendale, Glendale, and Burbank lines shows details of the history of the Red Car stops. The trolley started from downtown Los Angeles to Echo Park, went on to Edendale, then to Atwater with stops at Glenhurst Avenue, Atwater Avenue, and the Richardson stop (Seneca and LaClede Avenues) before crossing over the Southern Pacific railroad tracks to the city of Glendale and on to Burbank. (Courtesy Los Angeles Public Library.)

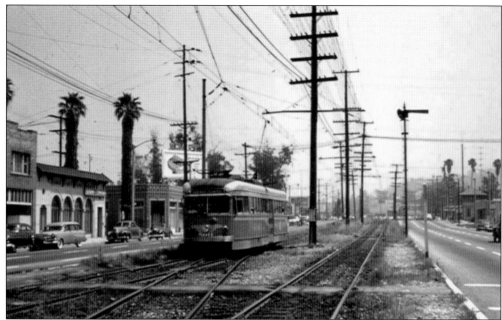

Metropolitan Coach Lines (formerly the Pacific Electric Railway) PCC No. 5011 rolls southbound on Glendale Boulevard in Atwater. Visible at the left-hand side of the photograph, at the corner of Seneca Avenue and Glendale Boulevard, is a building with arched windows and a doorway that is still in use today. On the far right side is the tower at the Richardson stop for the Red Car trolley. The photograph is dated May 28, 1955. (Courtesy Pacific Electric Railway Historical Society.)

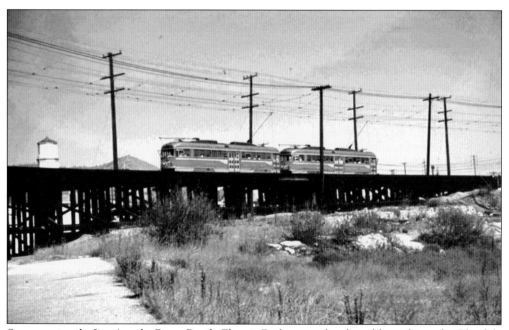

Seen crossing the Los Angeles River, Pacific Electric Railway cars head southbound over the Glendale Line's wooden trestle in this image dated October 15, 1949. Just visible on the left of the photograph is the tower of the Hyperion Bridge. (Courtesy Pacific Electric Railway Historical Society.)

Four

HOME SWEET HOME
WITH ATWATER FAMILIES

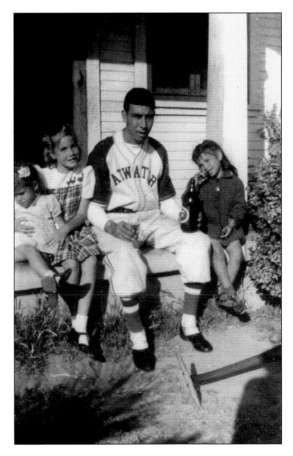

The Speed sisters—Jill, Joan, and Jackie—are pictured from left to right with their dad, Jack, dressed in his Atwater Merchants baseball uniform around 1944. The family is seated on the front steps of their home at 3341 Hollydale Avenue. Jack was the manager of Beach's Market for many years and was very involved in the community as a member of the Atwater DeMolay, the Kiwanis club, and the Atwater Chamber of Commerce. The very talented Speed sisters sang and danced at community events like the annual tree lighting. (Courtesy Joan Speed Pizzo.)

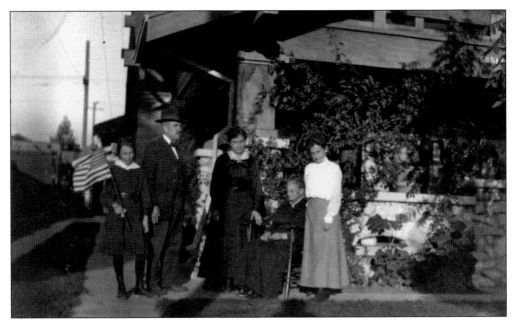

Standing in front of the Richardson house at 3519 Atwater Avenue around 1918 are, from left to right, Jani Richardson; W.C.B. Richardson II; his wife, Clara Zeese Richardson; Mrs. Zeese; and Emilie Zeese. The Richardsons had this house built for them in 1912. W.C.B. II was the eldest grandson of W.C.B. Richardson, owner of the Santa Eulalia Rancho. (Courtesy Bill and Susie Richardson.)

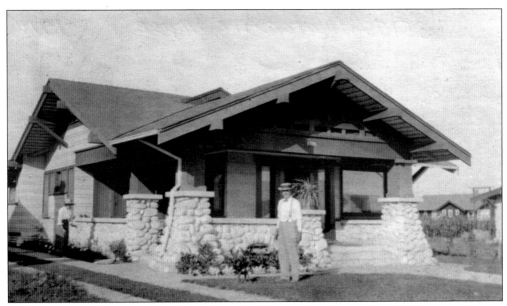

William Carr Belding Richardson II and his wife, Clara, work in their yard at 3519 Atwater Avenue. Later photographs show eight-foot-tall hollyhocks alongside the house where Clara is working. The house still stands today with some modification but is still recognizable as the Richardson home. (Courtesy Bill and Susie Richardson.)

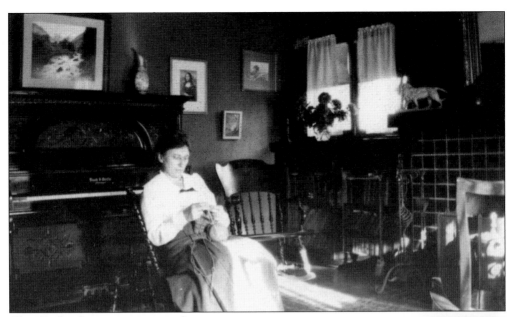

Clara Richardson is seen in a rocking chair knitting in the front room of her home at 3519 Atwater Avenue. Note the tile surround on the fireplace. Many tile surrounds in Atwater homes came from the local tile factory of the day on Los Feliz Boulevard. (Courtesy Bill and Susie Richardson.)

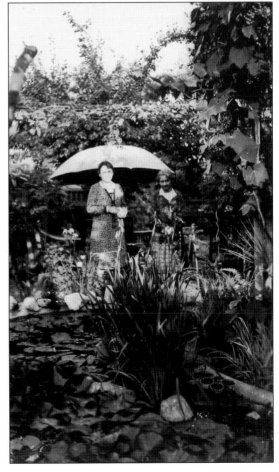

Clara Richardson loved gardening and took pride in her beautiful yard. Here she and her mother, Mrs. Zeese, are spending time in the dappled sunshine of the garden. (Courtesy Bill and Susie Richardson.)

The Forbes family came to Los Angeles from Clovis, New Mexico, in the 1920s following friends from the Church of God. They settled on Perlita Avenue near Verdant Street and used a house for their church. Pictured in this 1947 photograph are, from left to right, (first row) Clotilde, Karen, Glenne, Terry, and Darryl; (second row) Ivan, Warner, Vera, Elizabeth, Glenn, Erle, and Sylvia. Ivan Forbes remembers, as a young boy, seeing his four teenage neighbors across the street build a schooner on their property that had to be lifted out with a crane. The neighbors were the Weston family, who were famed photographers. Below is the Forbes family home at 4250 Perlita Avenue. The Forbes family lived in north Atwater Village until the 1950s when they moved to San Fernando Valley. (Courtesy Sylvia Forbes Busbee and Ivan Forbes.)

In the 1920s, a very dapper Charles "Chaz" Loya Madrid, left, and a friend pose in front of Madrid's home at 4112 Baywood Avenue. Madrid moved to north Atwater from San Elizario, Texas, and became a carpenter, wine salesman, and later an armament and electrical mechanic for the Lockheed Corporation. The Madrid family still resides in north Atwater after eight decades. (Courtesy Larry Madrid.)

Chaz Madrid, his niece, and a neighbor casually chat while sitting on the running board and luggage rack of Madrid's 1920s REO automobile. His white cap sits on the front fender. Madrid's sister Ruth sits behind the steering wheel of the windowless car in the driveway of their Baywood Street home. (Courtesy Larry Madrid.)

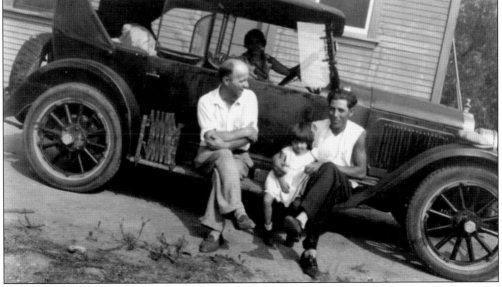

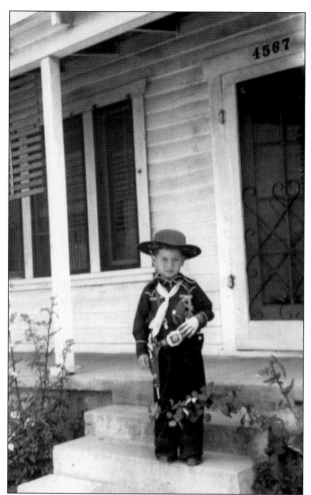

Five-year-old Larry Madrid, dressed in full Hopalong Cassidy cowboy regalia—with a scarf, hat, shirt, pants, holster, and big belt buckle—stands on the steps in front of his home at 4567 Brunswick Avenue in 1956. (Courtesy Larry Madrid.)

Pictured in 1947 from left to right, Charlotte Saldana, Eloise Saldana, Margie Sepulveda, and Sally Saldana pose in front of Margie's home at 4149 Baywood Street in north Atwater. The little white cottage bungalow was the first home of the Sepulveda family, which later moved to La Clede Avenue a few blocks away. (Courtesy Larry Sepulveda.)

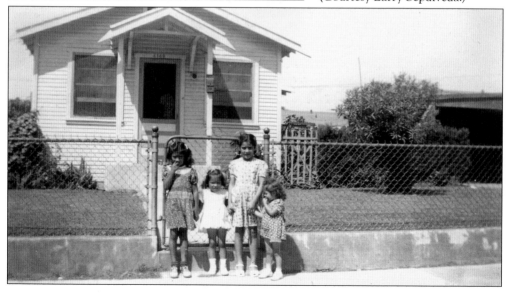

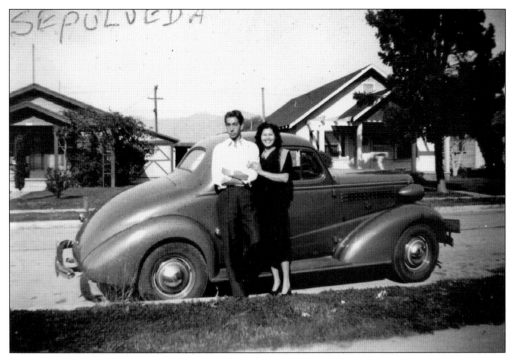

Joe and Nellie Sepulveda, newlyweds in this 1939 photograph, stand in front of their first car near their house on Baywood Street. The Sepulvedas moved in 1951 to La Clede Avenue, where they raised their children, Margie and Larry. Joe and Nellie never left the neighborhood, living there the rest of their lives. (Courtesy Larry Sepulveda.)

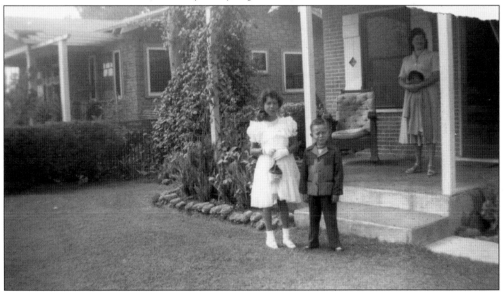

Margie and Larry Sepulveda stand in the front yard of their family home at 4306 La Clede Avenue. Their mother, Nellie, is on the porch. It is 1952, and seven-year-old Margie is about to make her First Holy Communion at the Cristo Rey Catholic Church around the corner on Perlita Avenue. Today, the house remains very original, with its green tile facade and white trim still intact, as well as a manicured yard. (Courtesy Larry Sepulveda.)

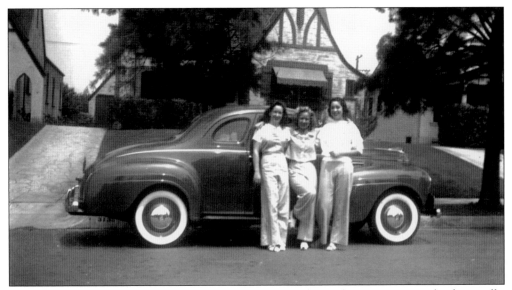

In 1940, three young ladies pose in their palazzo pants in front of a 1939 coupe with white walls. The English Tudor house in the background is located at 3135 Glen Manor Place in central Atwater Village. (Courtesy Los Feliz Improvement Association [LFIA] Historic Committee Archives.)

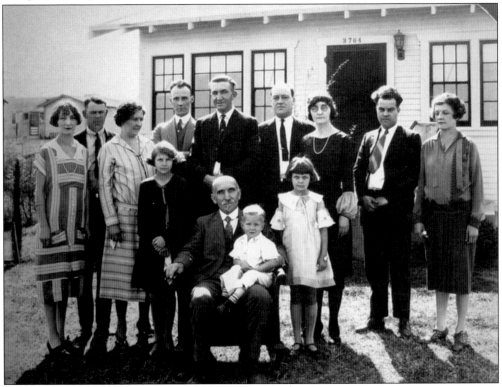

It is 1925, and several generations of the Dickman family, distinguishably dressed in attire of the day, proudly pose in front of their home at 3764 Glenfeliz Boulevard. In the 1940s, a two-story duplex was built in front of the house; both still stand today. (Courtesy LFIA Historic Committee Archives.)

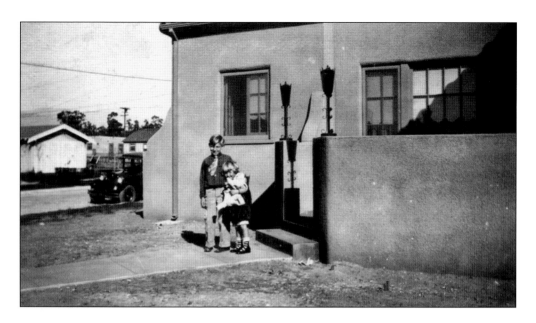

The photograph above was taken at 3743 Revere Avenue in 1925. Three-year-old Gloria and her seven-year-old brother, Leland, stand in front of the family's newly built home, pre-landscaping. Previously, their parents, Leland A. and Alma Sturges, and the children lived at 3707 Revere Avenue, where Gloria was born. Gloria attended Glenfeliz Elementary School from kindergarten through eighth grade. In the photograph below, taken at the same camera angle, Gloria, now a 15-year-old John Marshall High School student, is stylishly dressed and posed on the front lawn. The house is now fully landscaped with mature plants, and a decorative tassel awning adorns the house. Gloria has fond memories of playing tennis on Revere Avenue without a net, roller skating all over the neighborhood, and walking down to the river to pick wild watercress and celery. (Both, courtesy Laurel Schulman and Gloria Sturges Heyford.)

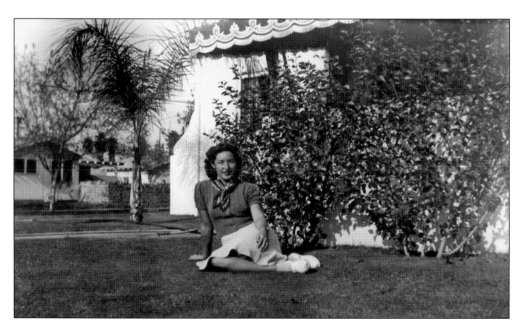

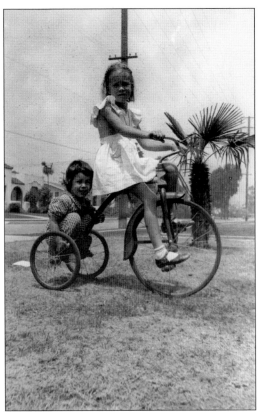

Joan Speed is giving little sister Jacquelyn a ride on the back of her tricycle. The four Speed sisters, Joan, Jacquelyn, Jill, and Jan, have fond memories of growing up in Atwater. They belonged to the Brownies, watched matinees at the Atwater Theatre, and attended Atwater community picnics in Griffith Park just across the river. They took dance lessons from local teacher Joan Lott and even performed at Doyle O'Dell's Kiddieland on Riverside Drive at Fletcher Drive. (Courtesy Joan Speed Pizzo.)

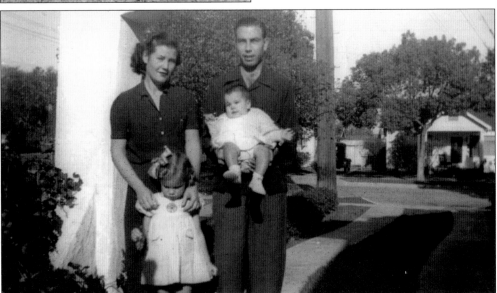

Nellie Beach Speed and her husband, Jack, with daughters three-year-old Joan and nine-month-old Jacquelyn, are pictured in the driveway of their home on Casitas Avenue around 1939. This photograph shows when Casitas Avenue still had houses on both sides of the street. Later on, most of the homes on the east side of the street were replaced by light industrial businesses. Nellie was the sister of Beach's Market owner Max Beach. (Courtesy Joan Speed Pizzo.)

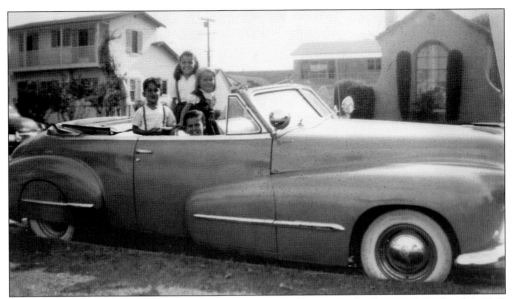

Pictured in this 1952 photograph is Joan Kinnon, standing in the back seat of the family's 1947 Oldsmobile with next-door neighbor James Ordonez standing next to her. On the front seat is her sister, Judy. Brother Jan sits by the door in front with just his head showing. The car was light blue with lots of extras, including push-button windows and twin spotlights, seen where the hood meets the windshield. Check out those big whitewall tires. (Courtesy Jan Kinnon.)

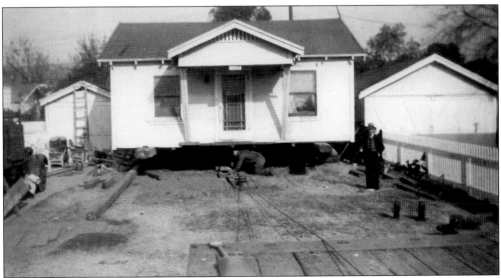

Some houses in Atwater were built at the back of the lot, leaving a long front yard with virtually no backyard. The Kinnon house was 900 square feet and cost $3,000 in 1943. The family moved the house forward in 1945, when a front porch and a bedroom were added. In the 1960s, two one-bedroom apartments were built in the backyard, one above the other, and each rented for $75 monthly. (Courtesy Jan Kinnon.)

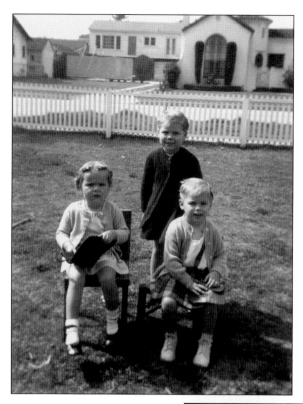

The girl on the left is two-and-a-half-year-old Judy Kinnon. This photograph was taken in March 1950. The girl standing is Penny Webster, and the girl sitting in front of her is her younger sister, Susie. They are playing in the front yard of the Kinnon house at 3169 Perlita Avenue. The Webster sisters lived just up the street with their parents and older brother, Pat. (Courtesy Jan Kinnon.)

Around 1949, the Worthington sisters, Muriel "Mimi" McDonald (right) and Jean McIntire, are pictured under a tree across the street from their family home at Atwater Avenue and Tyburn Street, where Mimi has lived since 1936. Both girls graduated from John Marshall High School. Mimi's jacket represents the Deputy Auxiliary Police (DAPS), which assisted the Los Angeles Police Department at the Police Show, had a sports program, and also hosted a camp at Mount Waterman called Valcrest. DAPS met at Central Police Station on Temple Street. When the United Nations was formed, they made a flag representing all the nations. (Courtesy Mimi McDonald.)

Betty Bartlotta is seen in front of her family's home in April 1956 at 3948 Edenhurst Avenue, shortly after her arrival from Rochester, New York. (Courtesy Betty Bartlotta.)

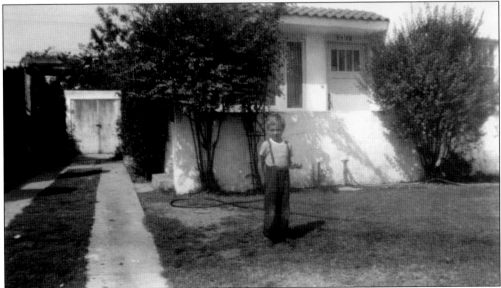

It is 1945 and six-year-old Rick Kelly is standing in front of his home at 3132 Perlita Avenue. Kelly has fond memories of being able to play outside all day with the neighborhood kids. The garages of the time, like the small single-car type shown here with the double swing-out doors, were built for cars of the 1920s. These days, most of them are used for storage or offices, since cars of today are wider and longer and will not fit inside. (Courtesy Rick Kelly.)

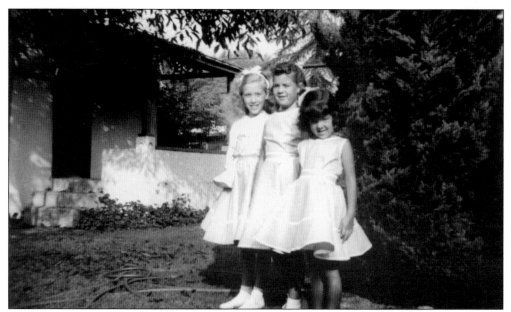

Standing in the yard of the Brasington home at 3123 Atwater Avenue are, from left to right, Sharon Starling and Sandra and Cynthia Brasington on their way to Atwater Avenue Elementary School dressed in matching outfits made by their mothers. Sharon, a friend and neighbor, lived on Perlita Avenue. The girls' two properties were back-to-back and shared a picket fence, with one missing picket giving the kids free access between houses. (Courtesy Brasington family.)

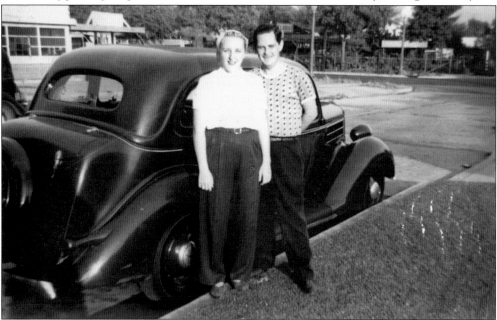

Atwater couple Ruth and Jack Kyburz, pictured around 1950, are standing near their home at 3114 Perlita Avenue at the corner of Perlita and Fletcher Drive. The Kyburzes proudly pose in front of their new car. The property across Fletcher Drive on the northeast corner was a florist and nursery until the early 2000s. The business on the northwest corner across Perlita Avenue was an upholstery shop. (Courtesy Dennis and Darcy Kyburz.)

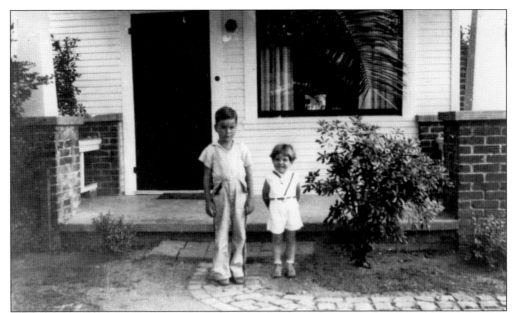

Standing in front of the family home at 3362 Casitas Avenue are brothers Ted and Don Bachardy. This photograph was taken in 1937, when Don was three and Ted was seven. The boys lived there with their mother, Glade, and father, Jess. Don left Atwater in the early 1950s, went on to study art, and became a noted artist, painting portraits of dozens of Hollywood stars and other notable personalities. (Courtesy Don Bachardy.)

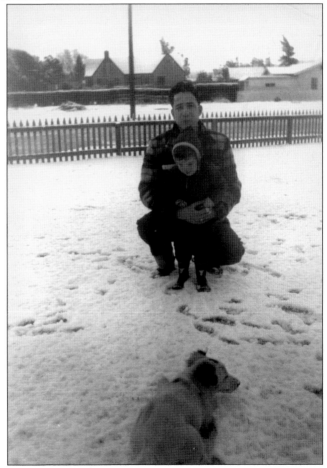

Millie Caravella took this picture of her husband, Vince, and son, Jody, and his dog, Rusty, in their front yard at 3254 Atwater Avenue. Snow falling in Los Angeles in February 1949 was a big surprise to residents. Kids and their dogs could not wait to get out and play in the snow. (Courtesy Caravella family.)

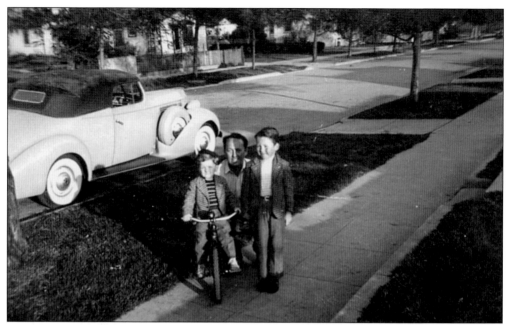

The Hawkins family lived at 3040 Atwater Avenue during the 1930s and 1940s. When they moved it was just minutes away to a new home on Edenhurst Avenue, still in Atwater Village. Shown in this photograph are Tommy Hawkins with sons Jimmy (left) and Tim. In this picture, Atwater Avenue extended much farther than it does today. Much of the block was lost when the 2 Freeway was built, leaving the block just six houses long. (Courtesy Bette and Jimmy Hawkins.)

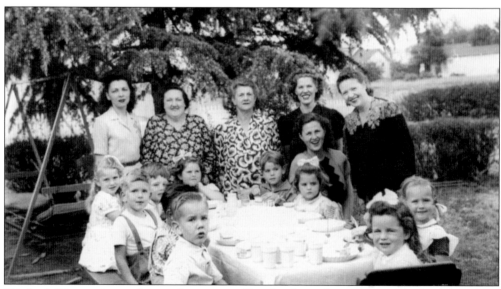

Elizabeth Kinnon is standing at the center of her family as they celebrate the birthday of her granddaughter Helen McGovern on June 5, 1947. This photograph was taken in the front yard of her home at the corner of Silver Lake Boulevard and Glenhurst Avenue. (Courtesy Jan Kinnon.)

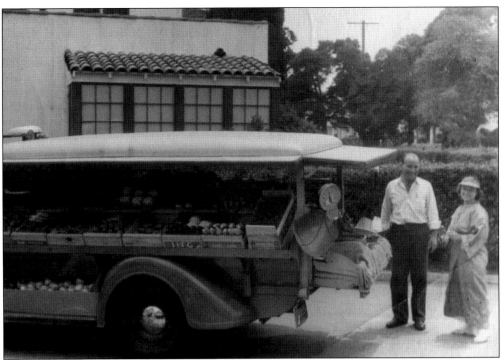

In the 1940s, Atwater resident Benjamin Malone and a customer stand next to his 1938 Dodge limousine, which was converted into a produce truck. The vegetables are well stocked and nicely displayed, along with two scales. Food vendor trucks were popular in the early days, before most housewives had cars. The trucks conveniently drove though neighborhoods, bringing ice, milk, produce, and baked goods to customers' doors. Golden Krust and Helms Bakery gave customers signs to place in their front windows to alert the drivers to stop. The photograph below shows the Malone home at 3202 Larga Avenue near Minneapolis Street, where Benjamin lived with his wife, Maxine, and son, Benjamin Jr., who would sometimes help his father on his route. Benny Jr. attended Atwater Elementary, Irving Junior High, and John Marshall High School, graduating with the class of 1958. (Both, courtesy Keith Malone.)

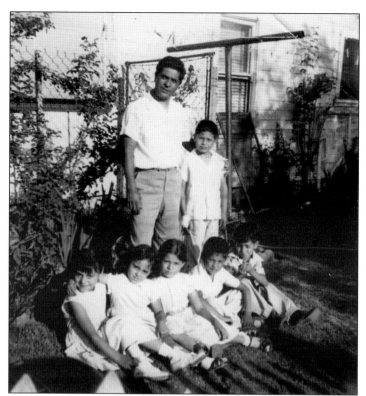

Around 1955, Cayetano Peraza, trying out his new camera, takes a photograph of his brother-in-law Frank Quinonez and his son Jimmy standing next to him in their backyard at 4026 Bemis Street. From left to right, cousins Nancy, Susie, Priscilla, Bacillio "Basil," and Eddie sit in the grass. The Quinonez and Peraza families lived next door while growing up in north Atwater. Below, around 1959, cousins Basil and Eddie fool around playing in the old washtub basin sink in their backyard on Bemis Street on a lazy Saturday morning. (Both, courtesy Nancy Peraza Franco.)

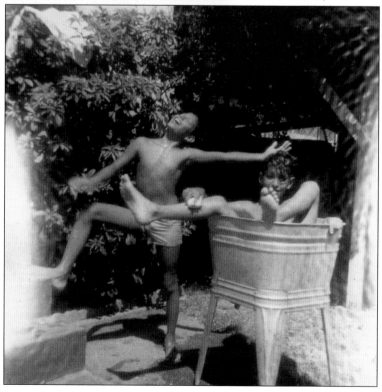

Five

IN AND AROUND THE VILLAGE

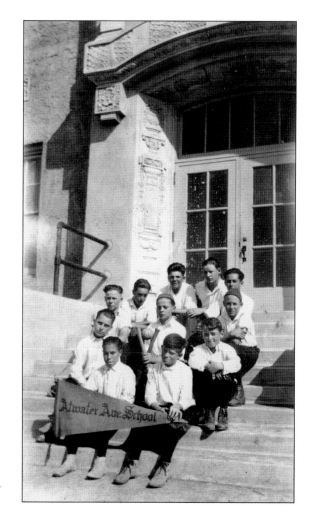

Students in front of Atwater Avenue Elementary School in 1929 proudly display their school banner. Atwater has been fortunate to have grammar schools, churches, its own library, and a post office, as well as many clubs and organizations within walking distance of most residents. Established in the 1920s, during the early days of the neighborhood's development, these resources gave Atwater a strong sense of community with a village feel. (Courtesy Atwater Avenue School.)

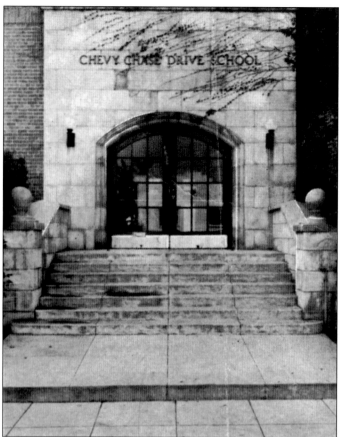

Chevy Chase Drive School is seen in the 1920s. The building had two entrances, one on Alger Street and the other on Chevy Chase Drive. The school closed in the late 1950s and sat abandoned for many years. Today, it is the site of the Chevy Chase Recreation Center. (Courtesy Sylvia Forbes Busbee.)

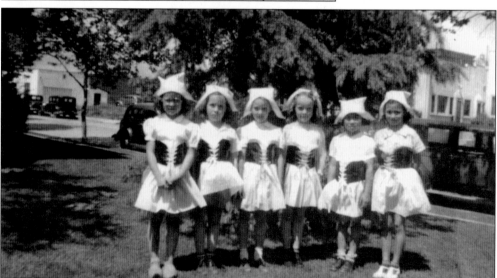

In the 1940s, third-grade classmates (left to right) Nancy, Jean, Sylvia, Donna, Kaziko, and Nadine stand on the east lawn under a big pine tree in the front of Chevy Chase Drive School on the Algers Street side. The girls are all dressed in little Dutch outfits, possibly for a school play. (Courtesy Sylvia Forbes Busbee and Ivan Forbes.)

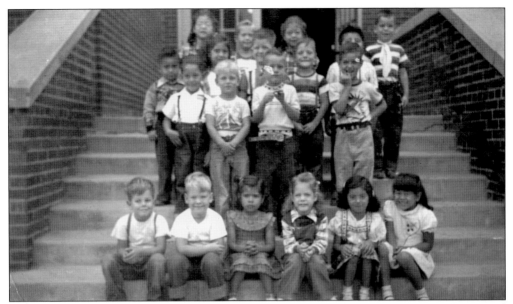

In 1952, first-grader Larry Madrid (first row, far left) sits with his cousins Norma, Mary, and Margaret (all in first row) and their classmates on the steps in front of Chevy Chase Drive School. Larry graduated from Chevy Chase Drive School and then attended Pater Noster High School, now Ribet Academy. (Courtesy Larry Madrid.)

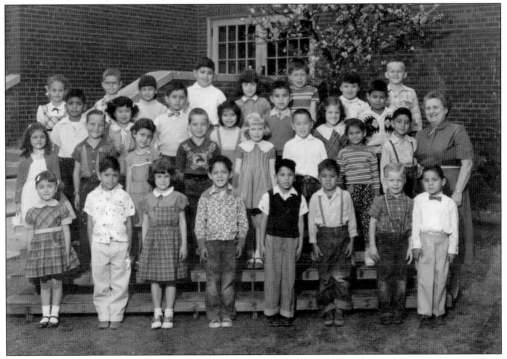

At Chevy Chase Drive Elementary School in 1959, first-grader Eddie Peraza, wearing suspenders, stands next to the teacher. This was the end of the road for the school—it would shut down the next year, and the students from north Atwater would attend Glenfeliz Boulevard School. (Courtesy Nancy Peraza Franco.)

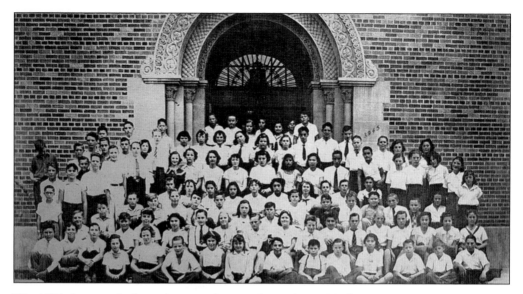

The 1935 photograph above shows students in front of Glenfeliz Boulevard Elementary School. The school opened in 1926. Students dressed in black and white pose in front of the original brick building with a beautiful arched entrance and ornate columns. At that time, the school included classes to the eighth grade. Pictured below is the sixth-grade graduating class of 1942 on the steps of Glenfeliz Boulevard Elementary School. (Both, courtesy LFIA Historic Committee Archives.)

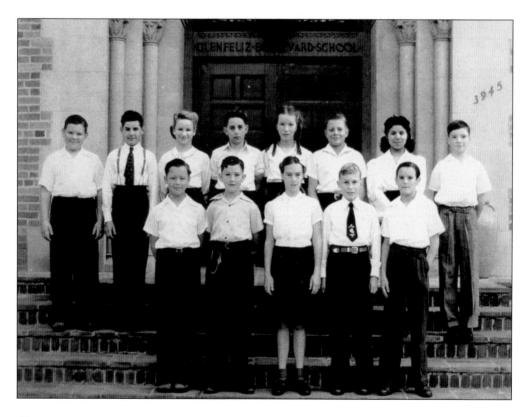

In 1922, land that had been lettuce fields was purchased and Atwater Avenue Elementary was founded as a provisional school with approximately 200 students. The permanent structure was started during the first year and opened during the 1923–1924 school year. Atwater was one of the first schools in the local area, built prior to Glenfeliz Boulevard Elementary, Washington Irving Junior High, or John Marshall High School. (Courtesy Atwater Avenue School.)

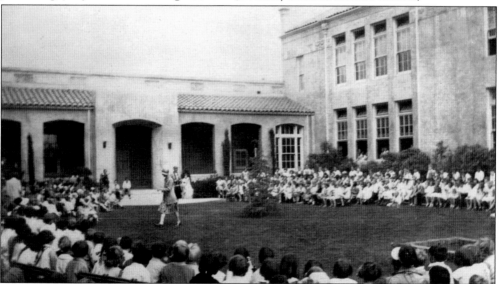

Atwater Avenue School, originally built to face Atwater Avenue, had matching two-story brick buildings connected by a breezeway and auditorium surrounding a center grassy courtyard. In this 1930 photograph, students, teachers, and parents are assembled for a spring program. The building on the right was for kindergarten through third grade, with the building on the left for grades four through six. The school was rebuilt in the 1970s, with the entrance moved to Silver Lake Boulevard. (Courtesy Atwater Avenue School.)

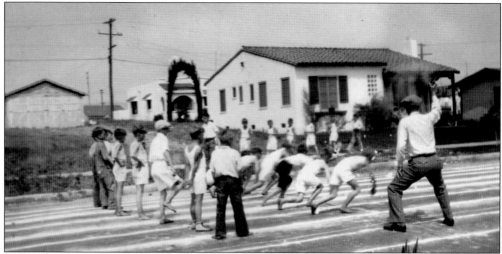

Atwater Avenue School kids participated in foot races on Perlita Avenue. This photograph from a 1929 Atwater Avenue School scrapbook shows barefoot students dressed ready to race. The smoke from the starter pistol rises above the head of the man at the start line. The house they are just about to race past still stands at 3381 Perlita Avenue. (Courtesy Atwater Avenue School.)

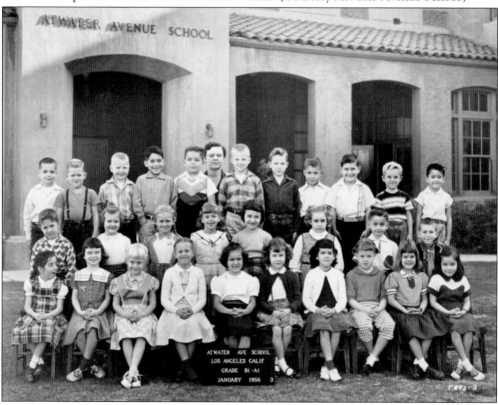

Sitting in the courtyard in front of the auditorium is Atwater Avenue School's first-grade classes of 1956. Cynthia Brasington, seated fourth from right, remembers her teacher, Ms. Fiefield, and girlfriends and classmates Kathy Figgin, Cheryl Scott, and Jill Wilcox. (Courtesy Cynthia Brasington.)

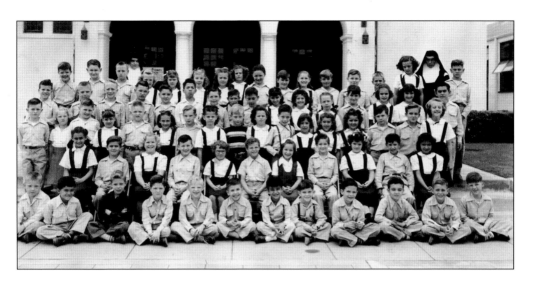

Holy Trinity School opened its doors on September 12, 1949. The photograph above shows the entire student body of 74 students in grades one through four. The school was located in the parish hall, which was divided to form classrooms on the north side of the church at 3722 Boyce Avenue. The teachers were Sisters of the Immaculate Heart. Jan Kinnon is pictured in the second row, second from the left, and his sister Joan is in the third row, fourth from the right. The picture below is of the student body in 1952. The school had grown to include grades one through seven and was still housed in the original classroom on the north side of the church. A new two-story, eight-room structure was constructed on the south side of the church in 1965. Principal Sr. Gabriel Marie is standing on the right side, Sister Theodore is on the far left with Sister Perpetua next to her. The pastor, Father Gallagher, is in the fifth row, on the right. (Above, courtesy Jan Kinnon; below, courtesy Joe Caravella.)

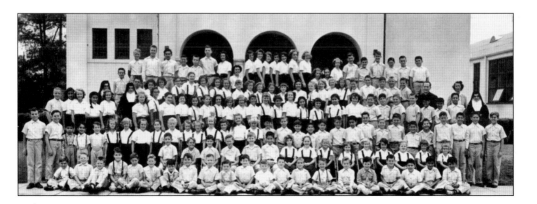

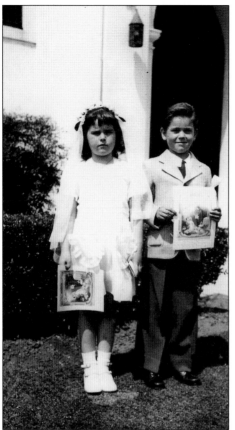

Jan Kinnon and his cousin Helen McGovern are pictured on Mother's Day, May 8, 1949, which was also a First Communion Day at Holy Trinity Church. Helen and Jan were in first grade at St. Bernard's School on Verdugo Road and Avenue Thirty-three because the Catholic grade school in Atwater would not open until the following September. Helen and her family lived on Silver Lake Boulevard at Glenhurst Avenue, and the Kinnons lived on Perlita Avenue. Jan still has the certificate he received that day. The 1950s photograph below shows children from the parish as they prepare to make their First Holy Communion. Parish priest Fr. Colm O'Ryan is standing on the left with the children. (Left, courtesy Jan Kinnon; below, courtesy Mimi McDonald.)

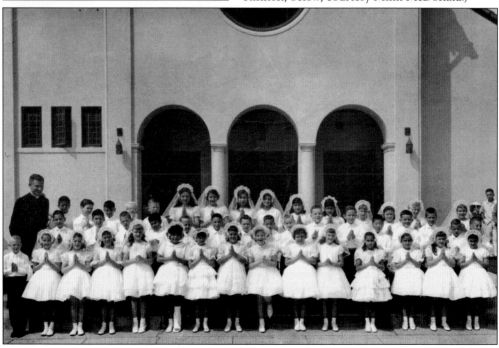

On February 15, 1925, Archbishop John Cantwell established a new parish under the patronage of the Holy Trinity. A rented house on Atwater Avenue served as the church and rectory. Later, Mass was said in a vacant store on Glendale Boulevard using a portable altar built by the men of the parish. The church was completed on October 4, 1925, and the First Mass at the new location was said. The parishioners represent the diverse ethnic mix of the families in Atwater Village. This photograph was taken in 1941. (Courtesy Holy Trinity Church.)

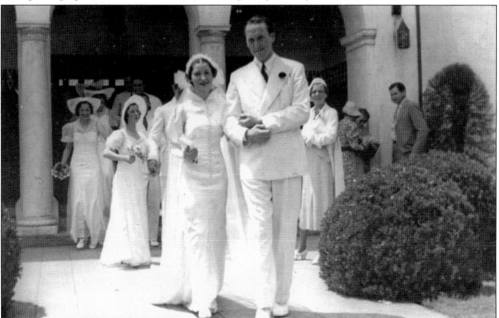

On April 25, 1937, Bette McMahon and Tommie Hawkins were married at Holy Trinity Catholic Church. They met while working at the Orpheum Theatre on Broadway in downtown Los Angeles. She was the head cashier, and he was the assistant manager. They were married for 56 years, and lived and raised their family in Atwater until Tommie's death in 1993. (Courtesy Bette and Jimmy Hawkins.)

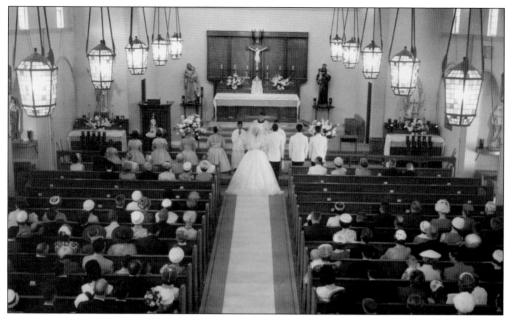

As the wedding invitation reads, "Mr. and Mrs. Nicola Corone request the honor of your presence at the marriage of their daughter Darlene to Mr. William Frederick Heinsberg on Saturday the fourth of August at 11 o'clock in the morning Holy Trinity Catholic Church 3732 Boyce Avenue Los Angeles, California 1962." This photograph shows the inside of the church during the wedding with its original hanging lamplights, pews, and altar. (Courtesy Darlene Carone Heinsberg.)

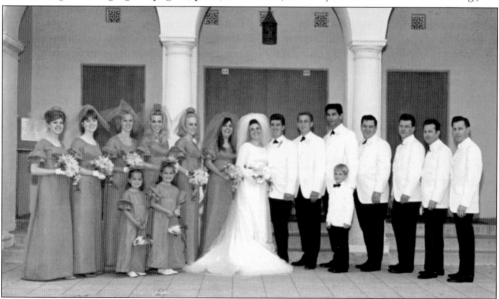

The Brasington-Caravella wedding party poses outside Holy Trinity Catholic Church on May 7, 1967. From left to right are Penny Schark, Lynn Sulkin, Judy Peterson Biermann, Tanya Morgan, Sharon McFadin Ruiz, Cynthia Brasington, Sandra Brasington Caravella, Joseph Caravella, Gordon Ochs, Victor Ruiz, Frank Tortorice, Joe Tortorice, Frank Rietta, and Phil Rietta. Flower girls were Michelle and Terry Smith, and the ring barer was Patrick Stewart. The Caravellas celebrated their 44th wedding anniversary in May 2011. (Courtesy Sandra Caravella.)

The Cristo Rey Church started out in a small rented house on Baywood Street that Fr. Jesus Domench used as his rectory and a temporary chapel. When the number of parishioners would no longer fit, Mass was held on his patio outside. Domench helped inspire the parishioners to raise funds to buy land for a permanent structure by holding dances, *jamaica* festivals, and fiestas. They purchased the land for their church in 1942. In the picture at right from 1943, construction is well underway. The photograph below shows the interior of the completed church at 4343 Perlita Avenue in 1944. (Both, courtesy Cristo Rey Church and Marie Delgado.)

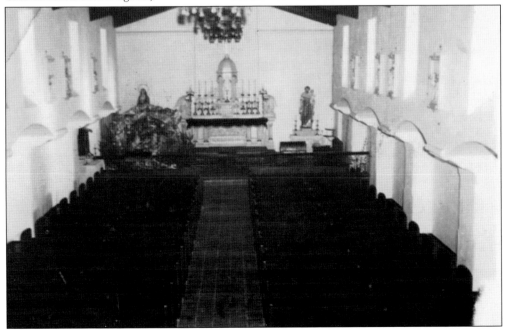

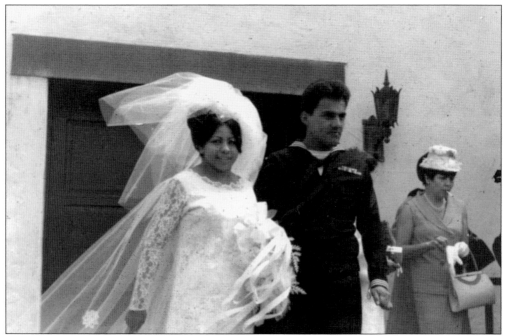

Around 1966, Norma Valenzuela and Andrew Arrendondo, who was home on leave from the Navy, pose in front of the Cristo Rey Catholic Church after their wedding ceremony. Ruth Hamilton removes her white glove to fire up a smoke. (Courtesy Larry Madrid.)

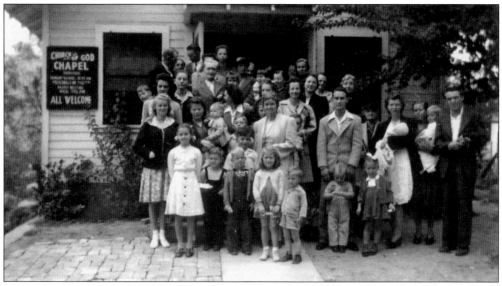

Pictured is the Church of God at 4254 Perlita Avenue in 1942. The multigenerational congregation stands in front of the chapel. The church originated in Clovis, New Mexico, and in the 1920s, some of its members came to the Los Angeles area, using this house as their chapel until the church moved in the late 1950s to Pacoima, where it still serves today. (Courtesy Ivan Forbes and Sylvia Forbes Busbee.)

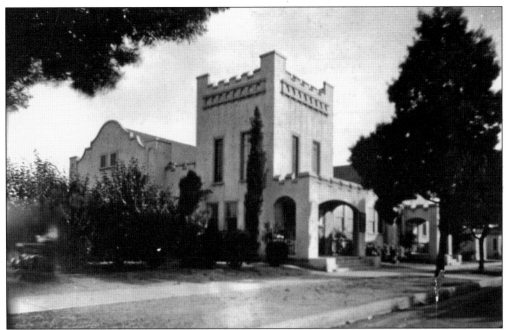

In March 1923, using three tents, the first worship and church school were held for the Atwater Baptist Church. The permanent church building was dedicated in 1924, with the present sanctuary constructed in 1949 on the corner of Perlita Avenue and Tyburn Street. The church has served the community in many ways over the years. The Atwater Park Center has been at this location for 40 years. (Courtesy Atwater Baptist Church.)

Griffith Park Christian Church was started in 1922 by Rev. J.W. Utter. A tent was erected at the corner of Brunswick Avenue and Glendale Boulevard, and a short time later, the property at the corner of Edenhurst Avenue and Gardenside Lane was purchased. The first building was completed in 1924 with later additions in the 1940s. One of the most beautiful parts of the church sanctuary is the stained glass windows that were installed on November 7, 1954. (Courtesy Pastor Bruce Fleenor.)

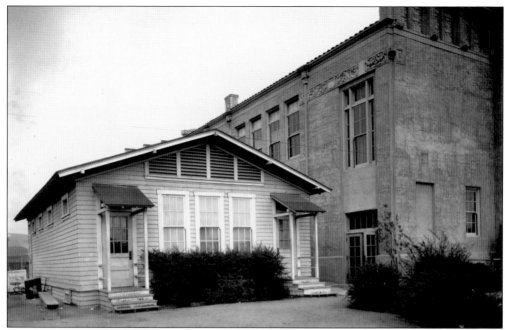

The first Atwater Branch Library began in 1923, one year after the opening of Atwater Avenue Elementary School. As requested by the Atwater Avenue Parent-Teacher Association, the Los Angeles Public Library opened the Atwater Library. It was housed on the school campus in a small wooden station house. The collection grew quickly, requiring new shelving, so the school provided a bungalow. By 1925, the Atwater station had become a fixture in the community. (Courtesy Atwater Avenue School.)

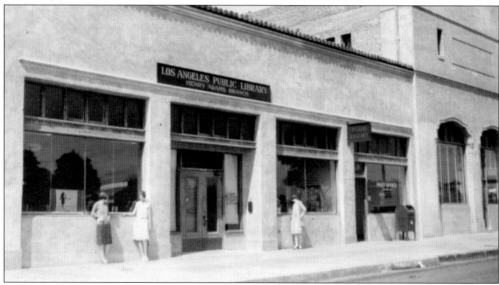

The Henry Adams Branch of the Los Angeles Public Library was opened in the newly built two-story Citizen's Trust and Savings Bank on Glendale Boulevard at Larga Avenue on November 18, 1927. The library was located on the ground floor behind the bank with the post office next door, now the site of Jill's Paint. The branch name honored author, historian, and editor Henry Adams. (Courtesy Los Angeles Public Library.)

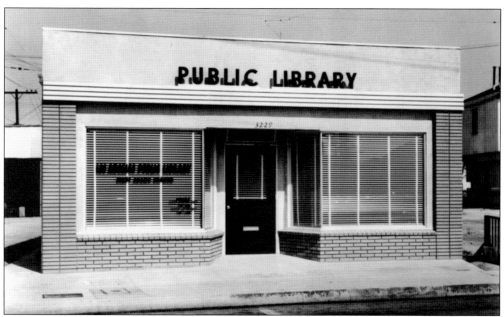

In 1952, the library was evicted from it location on Larga Avenue to make room for Sol's Market. F.W. Butler owned an empty lot at 3229 Glendale Boulevard, just across the street, and offered to build a storefront for the library. In 1953, Butler constructed an 1,820-square-foot building. On July 20, 1953, the community gathered to celebrate the reopening of the Henry Adams Branch Library. (Courtesy Los Angeles Public Library.)

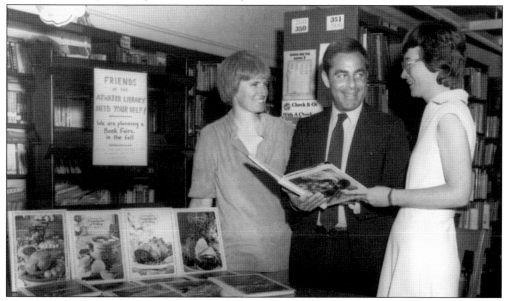

Friends of the Atwater Library formed in 1981. Pictured from left to right are Barbara Lass, president of Friends of the Atwater Library; Los Angeles councilmember Joel Wachs; and Joan Avery, Atwater Village librarian from the 1970s until her retirement in the 1990s. The upcoming book sale they are preparing for provided funding for the purchase of new books. The sale was held in the Episcopal St. Francis Chapel on Brunswick Avenue. (Courtesy Atwater Branch Los Angeles Public Library.)

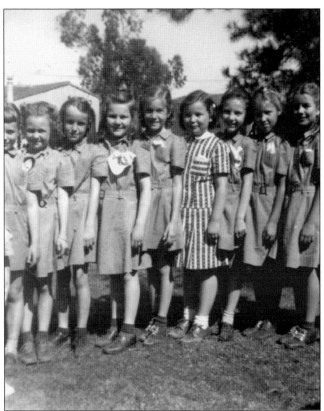

In 1945, local Atwater girls pose for a photograph in their uniforms as Brownie Troop 202. Joan Speed is standing in the center. (Courtesy Joan Speed Pizzo.)

In the 1950s, Cub Scout Troop 501 from Atwater Avenue School is on a day trip to Catalina. The mothers in charge are, from left to right, Courtney Tuma, Irene Catlin, Clara Anderson, and Millie Caravella. Some of the boys in the picture, in alphabetical order, include Bruce Anderson, Michael Booth, Joe Caravella, Gary Catlin, Charlie Myers, Jerry Peterson, Roy Sherman, Garth Tuma, and Edgar Wild. Gordie Ochs is on the right holding the life preserver. (Courtesy Joe Caravella.)

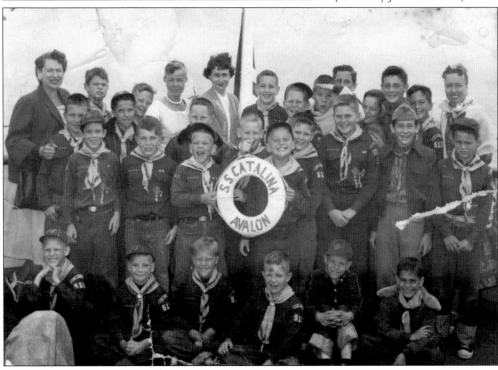

Joan Lott lived on Revere Avenue and ran a dance school for local kids in the studio on her property. In the 1950s, she moved her studio to the American Legion hall on Legion Lane. In this photograph, Jimmy Hawkins, the first boy on the left, joins other local kids at one of the regular recitals Lott gave to show off the talents of her students. (Courtesy Bette and Jimmy Hawkins.)

Mrs. Rossler's Music School—its students pictured here around 1944—was on Brunswick Avenue in north Atwater. She had a studio built in the back of her home. Many local children went there and learned to play the piano, accordion, and violin. Every year, she had a recital in the auditorium of the Chevy Chase Drive School. (Courtesy Ivan Forbes and Sylvia Forbes Busbee.)

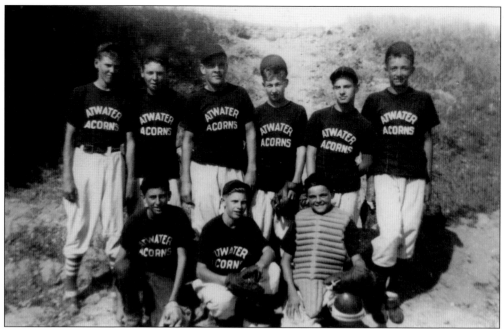

In 1942, the Atwater Acorns baseball team was mostly Atwater students who were then attending Irving Junior High. The players would walk from their homes in Atwater, over the Sunnynook footbridge, traversing the Los Angeles River into Griffith Park. The baseball diamonds were where the soccer fields are today. The next step for a player would be the American Legion team. Several members went on to play professional baseball. (Courtesy Bill Nadeau.)

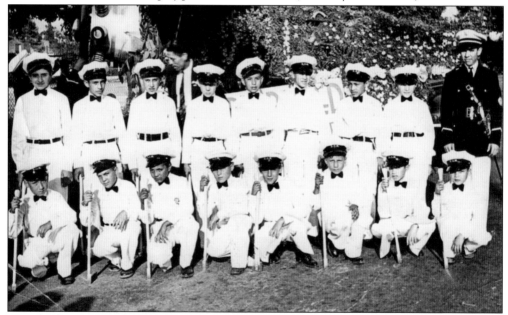

Team leader Loren Madrid proudly stands with his Camp Magnolia Branch of the Woodmen of the World youth drill team as they pose in uniform with their batons. Many children who lived in north Atwater participated in the group and attended the summer camp, which was sponsored by Omaha Life Insurance. The team marched in parades and attend fundraisers. (Courtesy Larry Madrid.)

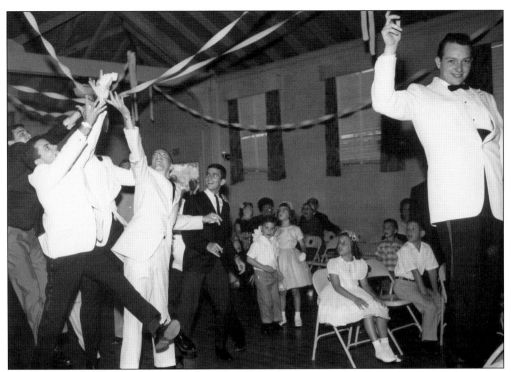

On Saturday, August 4, 1962, Darlene Carone and William Frederick Heinsberg were married at the Holy Trinity Catholic Church. Their reception was held a few blocks away at the American Legion hall at 3765 Legion Lane near the Los Angeles River. Above, young men in the photograph leap for the garter, and below, the beautiful bride throws her bouquet to the waiting young ladies. The Legion hall, Griffith Park Post 353, now a private residence, was once a bustling community asset and the center of activity for Atwater residents. The grounds had a volleyball court, and the hall had a stage. It was rented for wedding receptions, bingo, and casino nights, where local merchants donated prizes. Joan Lott taught dance classes there for several decades. Membership waned, and the remaining Legionnaires joined other posts. (Both, courtesy Darlene Carone Heinsberg.)

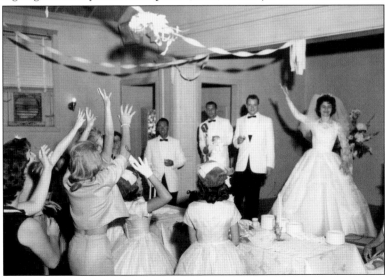

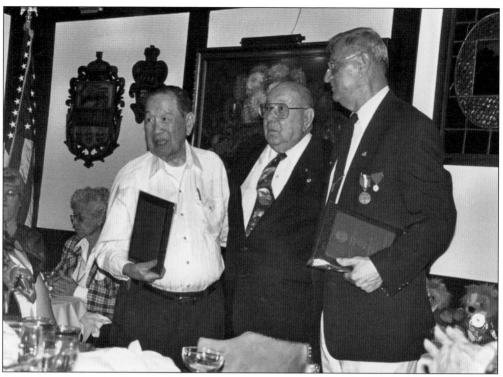

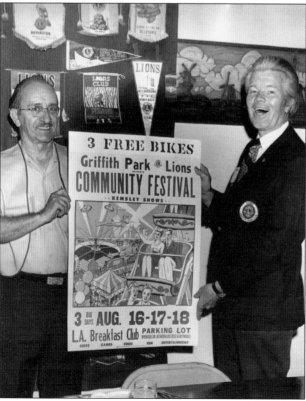

The Griffith Park Lions Club has been active in Atwater Village for many years. The Lions Club is a service organization that focuses on sight loss prevention programs, youth programs, and services for children. To raise funds to support Lions programs, an annual pancake breakfast is still held each May in the Wells Fargo parking lot. The photograph above was taken at an awards luncheon at the Tam O'Shanter. Frank Jung, left, Atwater businessman and owner of Jung and Jung Accounting since 1960 and a Lions Club member since 1975, is receiving recognition for his many years of service as treasurer. The photograph at left shows Lions members promoting a community festival they sponsored at the Los Angeles Breakfast Club in August 1975. President Harry Hartman is standing on the right. (Above, courtesy Frank Jung; left, courtesy Hartman family.)

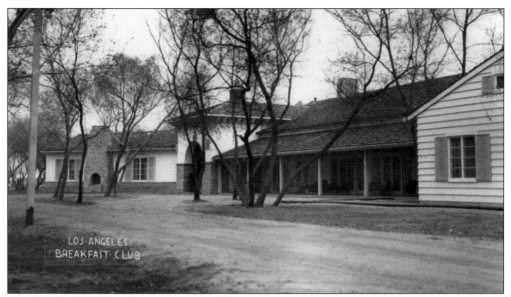

The Los Angeles Breakfast Club was established in 1925. "Not a church, not a lodge, not a service club but a shrine that friendship built" was one of its slogans. The club was started by a group of prominent businessmen who rode horses in Griffith Park on Friday mornings, and a chuck wagon would serve them breakfast after their ride. A member proposed they build a place where they could meet for breakfast and have events. The first clubhouse was built at 3201 Riverside Drive. In 1937, a new clubhouse was built at 3201 Los Feliz Boulevard, where it remained until 1965. These photographs show the newly built Los Feliz Boulevard clubhouse and the interior foyer. Some of the members were Tom Mix, Leo Carrillo, Cecil B. DeMille, and Edward Doheny. (Both, courtesy Los Angeles Breakfast Club.)

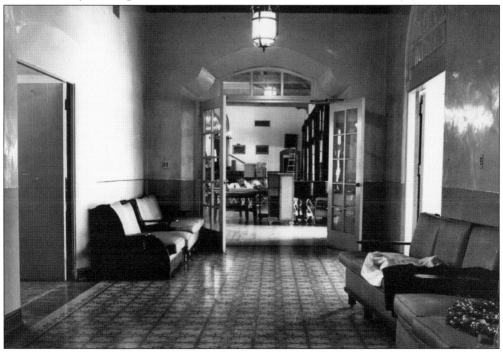

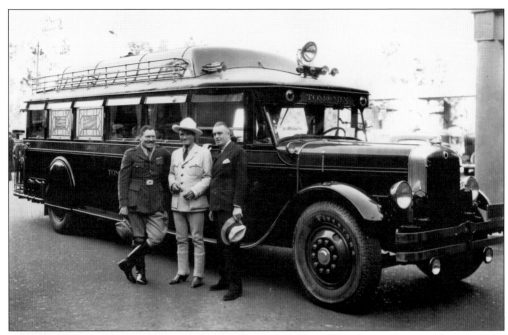

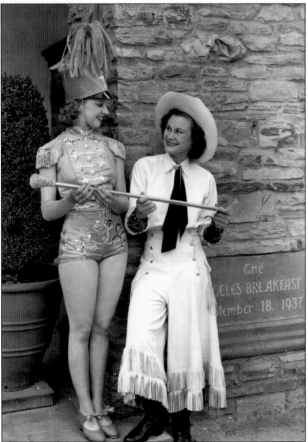

The above photograph shows actor Tom Mix (center) standing in front of his touring bus in the 1930s while attending a Los Angeles Breakfast Club event. The Breakfast Club had many social functions attended by celebrities, influential business leaders, politicians, movie stars, and dignitaries. The Tournament of Roses queen and her court always made their first official appearance at the Breakfast Club. In the photograph at left, a young majorette and a cowgirl stand in front of the Los Angeles Breakfast Club dedication plaque on the building at 3201 Los Feliz Boulevard. In later years, women were invited to become members and contributed greatly to the enhancement of the club's social atmosphere. One of the most popular clubs became the Las Senoras. Today, the Los Angeles Breakfast Club continues to meet weekly on Wednesdays at 7 a.m. at Friendship Hall on Riverside Drive. (Both, courtesy Los Angeles Breakfast Club.)

Six

MAIN STREET COMMERCE

-PLEASE MENTION THE INTERVIEW, WHEN ANSWERING ADS-

STRYKER'S 5&10¢ STORE	WHITE'S FOOD CENTRE	ATWATER SWEET SHOP
-School Started Today- We Have School Supplies 3170 Glendale Blvd.	High Quality Merchand- ize 3176 Glendale Blvd.	-Sandwiches-Eats- 3185 Glendale Blvd. -NO. 9172-
GLEZEN'S PHARMACY -Visit Our Fountain- 3100 Glendale Blvd. -OL. 3402-	THELMA'S WAVE SHOPPE For Appointment Phone OL. 0600-OL.0802(res) 3143 Glendale Blvd.	LE ROY'S CAFE -Fine Food & Hospitality- 3131 Glendale Blvd.
BOULEVARD LIQUOR STORE -Fine Liquors- -Open 12: to 6: P.M.- 3203 Glendale Blvd.	CLINTON DACE Barber & Beauty Shop -NO. 91134 3191 Glendale Blvd.	JANETTE STYLE SHOP -Smart Styles at Reasonable Prices- 3178 Glendale Blvd.
MARION MILLS-PRINTER -Wedding Invitations- 3141 Glendale Blvd. -MO. 1-3464-	SARGENT'S SERVICE ST. -Batteries Recharged- 3111 Glendale Blvd. -OL. 9374-	BOULEVARD BEAUTY SHOP -Permanent Waves- -NO. 2-3364- 3409½ Glendale Blvd.
ROSCOE M. SANDERS Real Estate-Insurance -Notary Public- 3127 Glendale Blvd.	RED FEATHER HARDWARE -Hardware-Paints- 3219 Glendale Blvd. OL. 1509--CI. 2-1091	PROCTOR and YOUNG -Groceries-Meats- 3411 Glendale Blvd. -OL. 9502-
B. & L. LIQUOR STORE Service With A Smile! 3542 Glenhurst Ave. -NO. 5648-	DE GROFF ELECTRIC Refrigeration Service -Back From Vacation- 3137 Glendale Blvd.	D.K. WHITTET -Roofing Contractor- 3409 Glendale Blvd. -NO. 5147-
BLAKE'S ATWATER PHAR. -Prescriptions Filled- -OL. 4308- 3200 Glendale Blvd;	TOM THUMB KIDDIE SHOP -Boys' & Girls' School Attire- 3150 Glendale Blvd.	BEACH'S MARKET -Fine Foods- -Quality Meats- 3104 Glendale Blvd.
HAROLD V. BRIGGS -Real Estate Broker- -NO. 2-5575- 3181 Glendale Blvd.	FROSTY'S BARBER & BEAUTY SHOP -Formerly Bob's- 3206 Glendale Blvd.	D.L. GOODRICH -Dry Goods- 3202 Glendale Blvd. -NO. 13412-
HIRTH HARDWARE& PAINT Sherwin Williams Paint 3152 Glendale Blvd. -OL. 6800-	EM-LYN DRESS SHOPPE Dresses-Suits-Lingerie 3239 Glendale Blvd. -OL. 2022-	DAINTY MAID BAKERY Back From Vacation to Serve You In Peace as in War!
ED'S BARBER SHOP "He'll Top Your Top!" Open Daily From 8:-6: 3143 Glendale Blvd.	ATWATER BEAUTY SALON -"Distinctive Perman- ents & Hair Styling" 3207 Glendale Blvd.	ROY WELCH BARBER SHOP -Two Barbers- 3389 Glendale Blvd. -Revere at Glendale-
H.R. MacNAIR Real Estate-Insurance 3169 Glendale Blvd. -OL. 3708-	O.M. HOUSE BIKE & KEY SHOP -Saws Sharpened- 3141½ Glendale Blvd.	DR. C.L. ANDERSON -OL. 5010-NO. 5374- (off.) (res.) 3151 Glendale Blvd.

-PLEASE PATRONIZE OUR ADVERTISERS-

This is the back page of a homespun newsletter called the *Atwater Interview* dated September 4, 1945. The advertisement page features local merchants on Glendale Boulevard, giving a view of the businesses along the boulevard 60 years ago. Not a whole lot has changed. A lifelong resident of Glenhurst Avenue recently found several copies of the *Atwater Interview* in a house in the San Fernando Valley while doing electrical work in an attic. (Courtesy Steve Skendzic.)

At the intersection of Fletcher and Riverside Drives in 1960, with Atwater in view just across the river, mounds of dirt and a large cement mixer stand at the construction site of the Interstate 5 Freeway. The stylish Chevron Standard and Richfield gas stations sit kitty-cornered. Across the street under the Currie's ice cream cone sign is a phone booth, and the streets abound with 1950s automobiles. (Courtesy Holyland Bible Knowledge Society, Inc.)

Foster's Old Fashion Freeze soft-serve ice cream on Fletcher Drive opened in the 1950s. During the 1950s and early 1960s, Paul Cimino and his wife owned the Atwater Foster's. The kids in the neighborhood made it a must-stop on Halloween, because the generous couple handed out a free nickel cone as their Halloween treat. In 1994, Fletcher Drive and Foster's Freeze were shown in scenes of the movie *Pulp Fiction*. (Courtesy Sandra Caravella.)

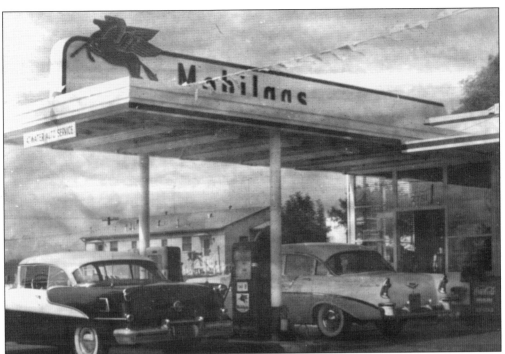

Around 1956, the Mobil gas and automobile service station is pictured with a 1956 Oldsmobile and a 1956 Chevy gassed up and ready to hit the open road. The station offered services such as oil changes and mechanical repairs to local residents. The property retains its original gas pump–area roofing but no longer carries the flying Pegasus. Located at 2751 Fletcher Drive, the building has been adaptively reused and is currently the home of Luis Lopez Automotive. It is pictured below when it was McMahon's Auto Service, an independent automobile repair shop through the 1970s and 1980s. The owner, "Mac" McMahon, had been a pilot in World War II and proudly displayed his service memorabilia in his shop. The gasoline storage tanks that were used when the location was a Mobil filling station were removed in late 1985. (Both, courtesy Luis Lopez.)

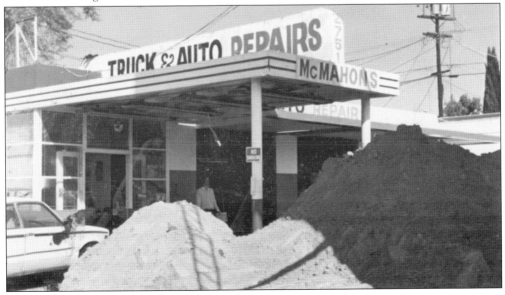

The photograph at left, from 1933, shows a Drive Service truck and driver looking over a heap of old tires. The company started out on Riverside Drive, just a short distance from its present location on Fletcher Drive at the corner of Larga Avenue. Drive Service specializes in repairing tires on trucks and big rigs. Pictured below is its fleet of service vehicles in 1975. (Both, courtesy Drive Service.)

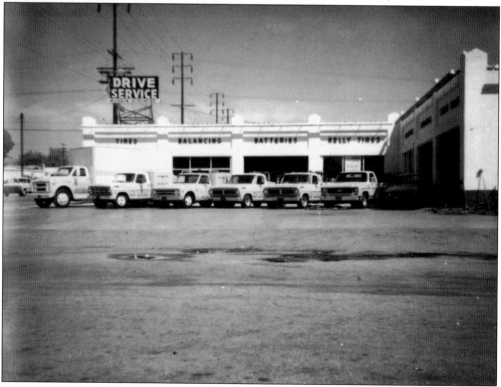

This house at 2645 Fletcher Drive was once the site of the Imahori Nursery and family home. The nursery ran parallel to the Los Angeles River through to Glenhurst Avenue. It carried general nursery stock and cultivated a field of pansies. It also sold Easter lilies and Christmas trees during the holidays. The Imahori family never returned to Atwater after they were taken to an internment camp during World War II. (Courtesy Saburo Imahori.)

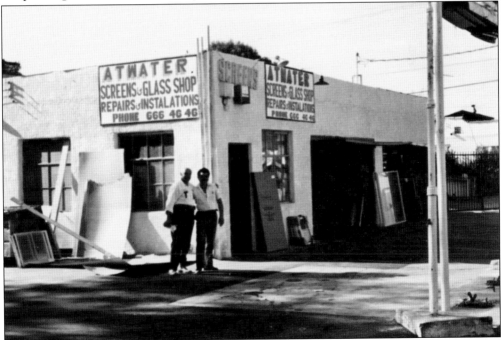

Around 1979, Armando Amador (right), owner and founder of Atwater Screens & Glass Shop, and fellow Fletcher Drive merchant Mr. Jozsa (left), owner of York Metal Sheet, stand in front of Amador's shop located at 2828 Fletcher Drive. This property was previous home to a gasoline filling station owned by the Smith brothers, George and Vincent. (Courtesy Atwater Screens & Glass.)

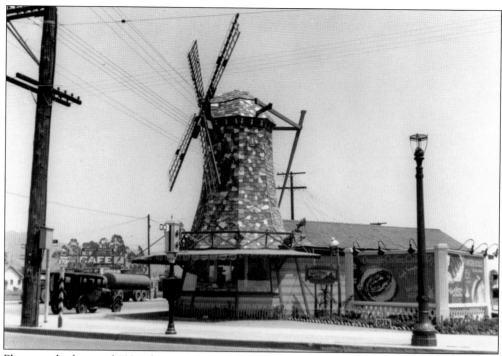

Photographed around 1921, this early Van de Kamp's Bakery windmill store on the corner of San Fernando Road and Fletcher Drive was designed by Harry Oliver, a set designer from the Willets Studio. The shingled roof and rotating blue windmill were quite unique, and they performed the double function of a retail outlet and a spectacular piece of outdoor advertising for the bakery. The bakery's motto was "Quality, Cleanliness, and Neighborhood Friendliness." (Courtesy Lawry's Restaurants, Inc.)

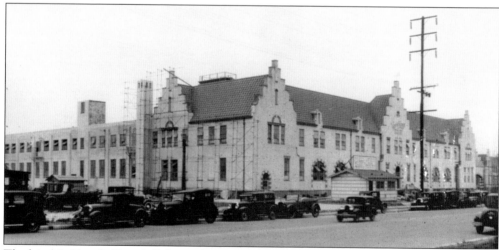

The historic Van de Kamp's Bakery administration building was built in the 1930s to resemble a Dutch 16th-century farmhouse. The headquarters for the chain of bakeries and coffee shops remains the only example of an industrial plant in the Dutch Renaissance Revival style. Conceived by New York architect J. Edward Hopkins, it was once dubbed the "Taj Mahal of Bakeries." It is seen here under construction with scaffolding in place and temporary offices on the job site. (Courtesy Lawry's Restaurants, Inc.)

84

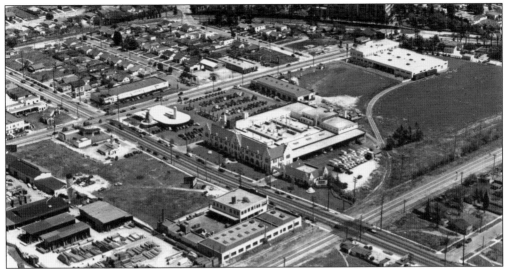

In this aerial view of the Van de Kamp's Bakery plant at 2930 Fletcher Drive around 1930, San Fernando Road crosses Fletcher Drive in the center of the photograph. The Valley Dairy Company sits across from the Van de Kamp's Bakery administrative building. Irving Junior High School, the Theme Hosiery (now the location of Ribet Academy), and Fitzsimmons Market are all visible along with two blocks of homes that were torn down to make way for the 2 Freeway. (Courtesy Los Angeles Public Library.)

This Van de Kamp's Bakery coffee shop menu is from May 6, 1951, when Lillie Gomez and a group of friends from Sacred Heart High School dined together. Visible are signatures on the menu that Gomez kept as a memory of the dinner her classmates had together. The menu choices are pure Americana, and the prices bring back memories of another era. (Courtesy Art Gomez Reyes.)

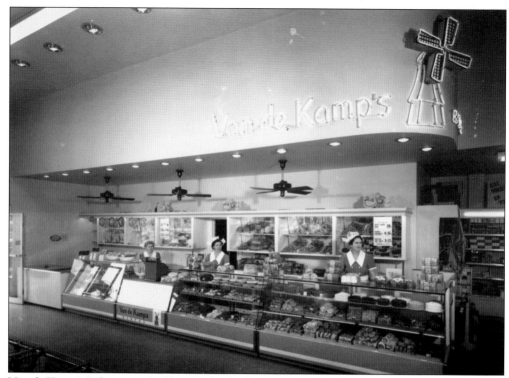

Van de Kamp's Bakery supplied hundreds of delicious baked goods to its coffee shops and markets throughout Los Angeles County. Salesladies in their starched Dutch hats with blue and white uniforms were typical at any Van de Kamp's Bakery counter. Dozens of Atwater residents were employed at the bakery and could walk to their jobs, like the woman on the left, who lived on Perlita Avenue, just three short blocks from work. (Courtesy Lawry's Restaurants, Inc.)

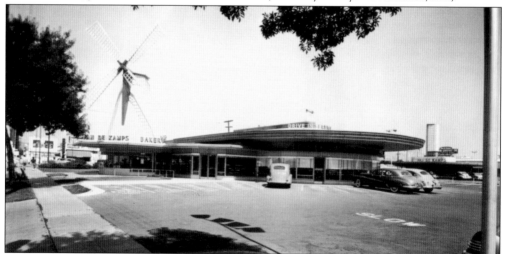

Van De Kamp's Bakery drive-in coffee shop stood at the corner of Fletcher Drive and San Fernando Road in the 1930s. The famous trademark blue neon windmill marked the spot where delicious food and freshly baked goods were sold. Freshness was assured, since the bakery facility was next door on Fletcher Drive. Residents from the surrounding neighborhoods enjoyed the wonderful aroma of just-baked products. (Courtesy Lawry's Restaurants, Inc.)

Longtime Atwater Village resident Tommy Hawkins crosses Revere Avenue as he strolls east down Glendale Boulevard past the local liquor store and pharmacy. His wife, Bette, took this photograph in 1937. Notice the ornate details of the street lighting and neon signage. The Atwater Village branch of the Los Angeles Public Library now occupies the site where the drugstore stood. (Courtesy Bette and Jimmy Hawkins.)

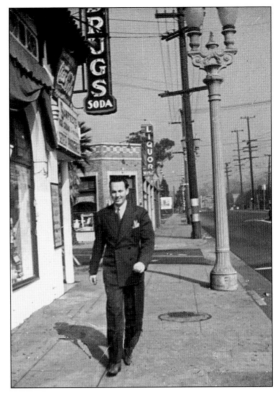

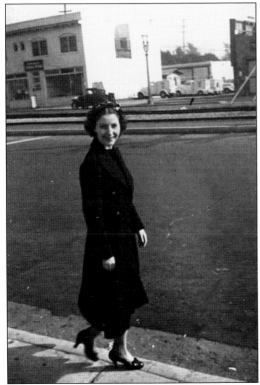

Bette Hawkins walks along the north side of Glendale Boulevard. The Pacific Electric Railway tracks can be seen running down the middle of the boulevard. Bette was on her way to the local streetcar stop as she traveled downtown to her job as head cashier for the Metropolitan Theatres. On the south side of the boulevard is the Carnation Ice Cream plant with its white ice cream trucks parked outside. (Courtesy Bette and Jimmy Hawkins.)

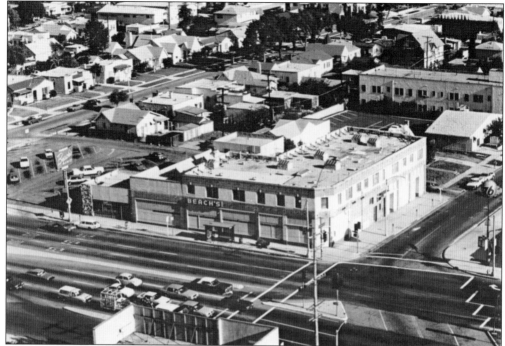

Beach's Market was on Glendale Boulevard between Madera and Glenhurst Avenues in the 1970s. Beach's opened in 1935 and was the neighborhood supermarket of its time. It remained a local favorite until its closure after the 1988 earthquake. A strip mall currently occupies the site. (Courtesy Beach's Corporation.)

The D. McMahon Plumbing truck is parked in front of the shop at 3423 Glendale Boulevard, across the street from the Carnation Ice Cream factory (now Pet Lovers). Dean and Dennis McMahon (Bette's aunt and uncle) adopted her after her parents died when she was just a year-and-a-half old. Bette and her family rented houses on Revere and Garden Avenues before moving in above the plumbing shop in 1935. The McMahons ran the business from 1932 until 1952. (Courtesy Bette and Jimmy Hawkins.)

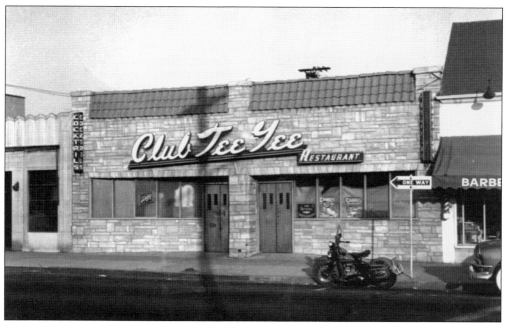

Club Tee Gee (above), at 3210 Glendale Boulevard, was originally opened in 1946 by owners Joe Grzybowski and Neal Tracy ("Tee" for Tracy and "Gee" for Grzybowski). In 1962, Joe was introduced to Betty Bartlotta, who lived with her family in Atwater Village and worked as a secretary at another business on Glendale Boulevard. Bartlotta and Grzybowski, seen below at Club Tee Gee in 1967, grew close and eventually became business partners in Club Tee Gee. Sadly, Grzybowski passed away in 1984. Bartlotta continues to run the club. Over many years, Club Tee Gee has survived, providing a friendly *Cheers*-like neighborhood place to meet and have a cocktail. (Both, courtesy Betty Bartlotta.)

This 1950s advertisement for the Atwater Theatre is from the *Griffith Park News*. The neighborhood theater at 3130 Glendale Boulevard (now Pampered Birds) was owned by Harry Owens, a television and radio personality of the era. Owens decorated the theater with beautiful murals of Hawaii that depicted mountains, waterfalls, and beach scenes. The carpets and stage curtains had bold tropical leaf and flower patterns. Saturday matinees featured serials, cartoons, newsreels, and two movies—all for only 14¢ and 6¢ for candy. (Courtesy Los Angeles Public Library.)

Local residents Giovanna Sims and Mary Lou Kinney started the Encore shop at 3135 Glendale Boulevard (currently Grain Furniture) in 1974. Sims and Kinney took nearly-new women's clothing to be sold on consignment. Kinney changed the store from consignment to retail and continued to run the shop for the next 22 years, making weekly visits to the Los Angeles garment district to find loyal customers their perfect items. (Courtesy Sheila Kinney.)

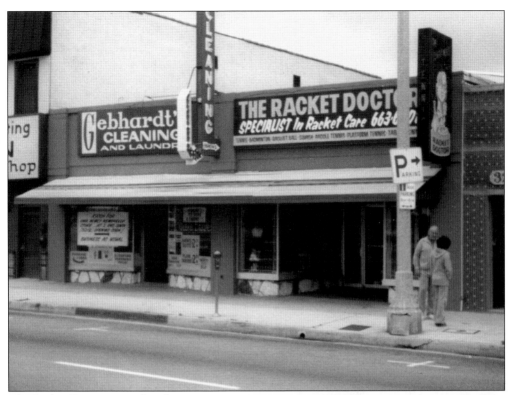

The Racket Doctor opened its door for business in 1970 at 3214 Glendale Boulevard. As a specialty shop for all things tennis related, it enjoys a loyal clientele from all over the city. It is especially convenient for those playing tennis at the courts in Griffith Park just across the Los Angeles River, less than a half-mile from the shop. It is owned and operated by Randy Kramer, who grew up in Atwater. Next to the Racket Doctor is Gebhardt's Cleaning, also a longtime business still in operation. (Courtesy Randy Kramer.)

Chinese restaurant Dennis Kitchen opened on February 14, 1968, Valentine's Day. Owner and operator Dennis Lee was an Atwater resident who lived for a time just up the street from his business. The restaurant featured a large cocktail lounge and banquet facilities. Lee sold the business, but it remains a Chinese restaurant on the corner of Garden Avenue and Glendale Boulevard. (Courtesy Dennis Lee.)

The Dutch American Bakery served the community for many years. This is a picture of it from May 1982. The bakery has changed hands several times, becoming the Rolling Pin Bakery, Tony's Bakery and Café in the mid-2000s, and now Proof Bakery at 3256 Glendale Boulevard. (Courtesy Sandra Caravella.)

The Hobby Stop was located on Glendale Boulevard and was a favorite spot for school kids. The shop was owned and operated by Ira Katz, who offered a wide assortment of model kits along with crafts of all kinds, miniatures for dollhouses, scientific projects, and hobby books. This photograph from 1950 shows the shop window with a sign promoting the use of the local library. (Courtesy Los Angeles Public Library.)

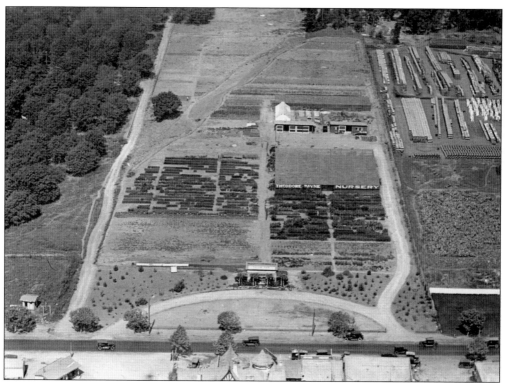

In 1922, Theodore Payne, a prominent, world-renowned horticulturist, opened his 10-acre nursery at 2969 Los Feliz Boulevard. He specialized in wildflower seeds and native plants. Through the years, many well-respected botanists and noted plantsmen made time to visit Payne at his nursery. He introduced into cultivation more than 430 species of wildflowers and native plants during his lifetime. The nursery had a small retail building, a large lath house, and acres of plants. On the left of the nursery is Perlita Avenue, a dirt road running alongside an orchard—one of the last remnants from Atwater's farming days. Cars are traveling down a paved Los Feliz Boulevard, and across the street is the Tam O'Shanter Inn. Below is a 1927 photograph showing the nursery building with mature landscaping. (Above, courtesy Los Angeles Public Library; below, courtesy Theodore Payne Foundation.)

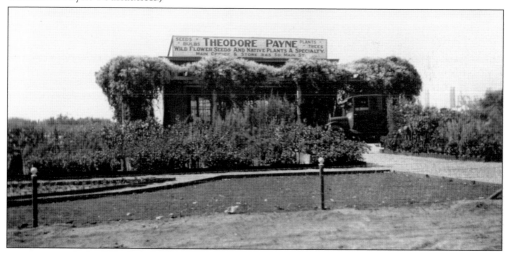

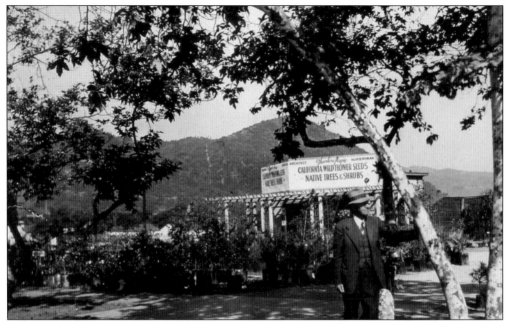

Theodore Payne stands in front of his nursery with Griffith Park's Beacon Hill in the background. After moving the nursery to Atwater, he carried on his passion to share and preserve wildflowers and the native landscape of California. Payne ran the nursery until he retired in 1961 at 90. Payne and his wife, Alice, lived on Revere Avenue and Dover Street. The Theodore Payne Foundation carries on his work. (Courtesy Theodore Payne Foundation.)

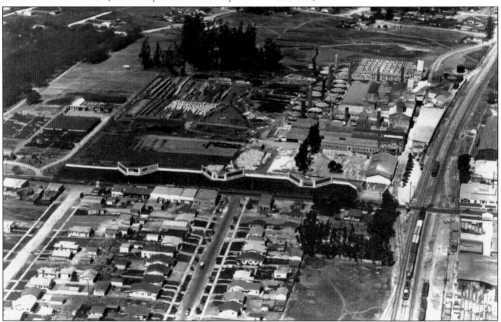

This 1920s aerial photograph shows the site of the Gladding-McBean Tile factory, producers of the Franciscan line of dinnerware, at 2901 Los Feliz Boulevard. In the background is north Atwater Village. A Van de Kamp's Bakery store with a windmill sits on the corner of Revere Avenue and Los Feliz Boulevard. (Courtesy Los Angeles Public Library.)

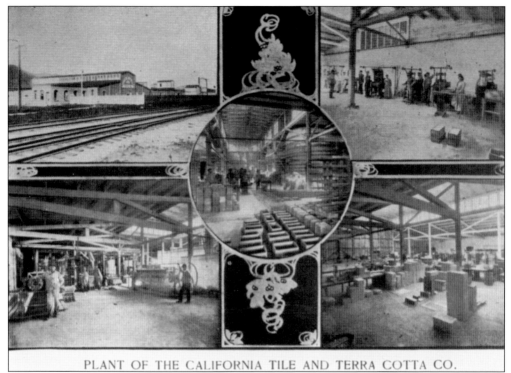

PLANT OF THE CALIFORNIA TILE AND TERRA COTTA CO.

This c. 1912 postcard gives a detailed overall view—with workers posing for the camera—of what a large operation the California Tile and Terra Cotta Co. factory was. The 45-acre site was shared with other companies that made building blocks, bricks, and water and sewer pipes. In its thriving years, the factory employed 300 people. (Courtesy Los Angeles Public Library.)

These huge kilns, located in the yard of Tropico Potteries, produced millions of products through the 80 years that the factory was open. In the 1920s, they produced interior and exterior faience tiles for storefronts, wainscoting, counters, soda fountains, and fireplaces. The staple products were architectural terra-cotta and sewer pipes used in the local building boom of the Roaring Twenties. Many Atwater homes still have their original terra-cotta tile roofs. (Courtesy Los Angeles Public Library.)

Bonifacio Madrid is seated at the far right of the second row with his coworkers at the Gladding-McBean Tile factory on Los Feliz Boulevard in the 1930s. Like many workers of the factory, he lived in the neighborhood, so he could walk to work. The factory provided many jobs to Atwater families, and many employees made it their lifelong career. (Courtesy Larry Madrid.)

Women workers at the Gladding-McBean Tile factory around 1928 include Rebecca Sanchez (far left) and Melissa Soto (second from left). In 1934, the factory began producing Franciscan ware, and many Atwater women worked at the factory painting the famous Franciscan Desert Rose and Franciscan Apple pattern dishes that adorned their families' dining tables. The facility closed in 1984. (Courtesy Los Angeles Public Library.)

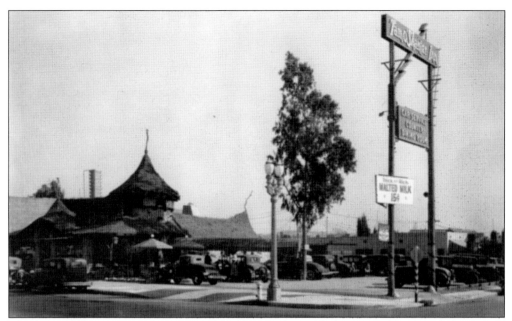

The Tam O'Shanter Inn, pictured in the 1930s, had a roadside sign with a neon lighting bolt advertising car, counter, and dining room service. Another sign below shows malted milk offered for 15¢. The progressive owners started many trends in the restaurant business, one being the first to serve patrons meals in their cars. The Tam O'Shanter has been remodeled several times, and each time, it was made to look older. (Courtesy Lawry's Restaurants, Inc.)

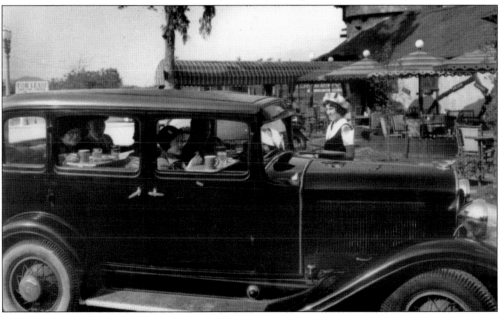

A waitress dressed in a Scottish uniform serves diners in their car at the Tam O'Shanter Inn in the 1930s. One of the proprietors, Lawrence Frank, invented the wooden trays on which the motorists would dine. Advertising written by Walter Van de Kamp invited the restaurant's guests to sample its "Car service deluxe—an ingenious feature that enables you to sit and eat in the comfort and privacy of your own automobile." (Courtesy Lawry's Restaurants, Inc.)

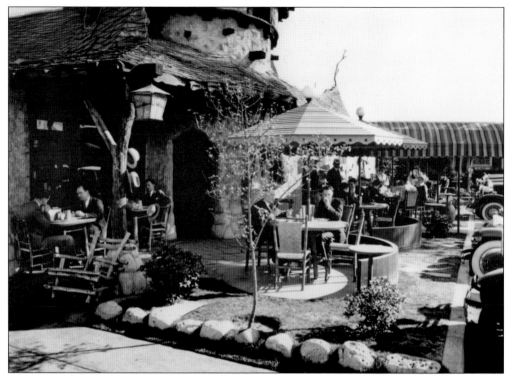

At the Tam O'Shanter Inn in 1933, diners sit outside under wooden umbrella-topped tables in the beautiful California weather. The majority of customers were ordinary people who worked across the street at the tile factory. Many came from the train station, which was walking distance from the restaurant, and others were part of the nearby horse community. Adding to the diversity of clients were the early movie industry stars and moguls, making it a celebrity-watcher's paradise. (Courtesy Lawry's Restaurants, Inc.)

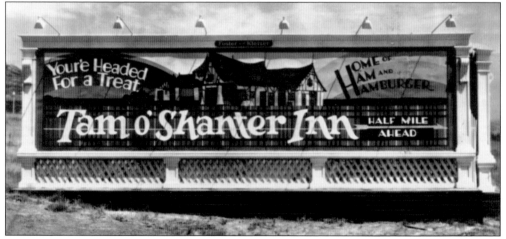

In the 1920s, a Foster and Kleiser roadside billboard sits on the unpaved road, possibly near Riverside Drive and Los Feliz Boulevard. The Tam O'Shanter Inn, with its whimsical style, looks so inviting, especially with the slogan "Home of Ham and Hamburgers." Diners today still enjoy the rustic Scottish charm and delicious food it has been serving for generations. (Courtesy Lawry's Restaurants, Inc.)

In the 1960s, longtime Atwater Village resident and community volunteer Cessiah Vasquez Lane stands on Los Feliz Boulevard close to present-day Darla's Dog Wash. In the background is a partial view of the sign for Uncle John's Pancake House. Also seen are two faint signs that say "Stable" and "Rent." (Courtesy Cessiah Vasquez Lane.)

Eatz Café is a local favorite. The Jabour family stands in front of the restaurant at 3207 Los Feliz Boulevard. Marie (center) and her daughter Robin (left) ran the business until they retired in 2006. The building is a portion of a Quonset hut with a large patio overlooking the par-three, nine-hole Los Feliz Municipal Golf Course. The restaurant still thrives today with a new owner. (Courtesy Robin Jabour Winn.)

A local family comes to shop at Vince's Market, get haircuts for the boys at Hill's barbershop, and make a visit to Mitzy's beauty shop for mom. The small building on the corner of Atwater Avenue and Silver Lake Boulevard housed all three businesses in less than 1,500 square feet. Pictured in front of the original streetlamp is the Rietta family. From left to right are Frank Jr., a friend, Mayna holding Phil, and Frank Sr. (Courtesy Caravella family.)

Silver Lake Boulevard, a main street in the southern section of Atwater, was zoned for light commercial business, and almost every block along the boulevard had its own small grocery store. This photograph, taken in the 1940s, is of Bill's Market at the northwest corner of Silver Lake Boulevard and Atwater Avenue, with another market just across the street on the southeast corner. There were three other small family markets along the street: Parnell's, Marie's, and Queen's. (Courtesy Caravella family.)

This photograph was taken in February 1949, when it snowed in Los Angeles. It shows a thin blanket of white covering a picket fence–enclosed yard. Across the street are Vince's Market, Hill's barbershop and Lee's Beauty Shop. Two of Atwater's original lampposts are visible on the corners. (Courtesy Caravella family.)

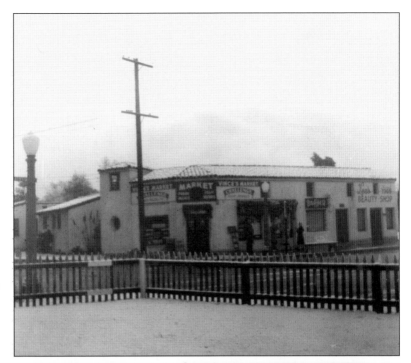

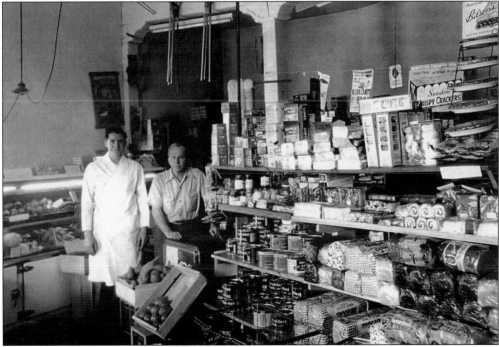

Vince's Market, a local neighborhood mom-and-pop market, served the community, carrying everything from mops and brooms (seen hanging from the ceiling) to bread, milk, and fresh produce. Pictured here are owners Vince and his father, Joe "Big Daddy" Caravella, who bought the market in 1939 after coming to California from Alabama. In the 1970s and 1980s, it was home to the 50¢ ham and cheese. (Courtesy Caravella family.)

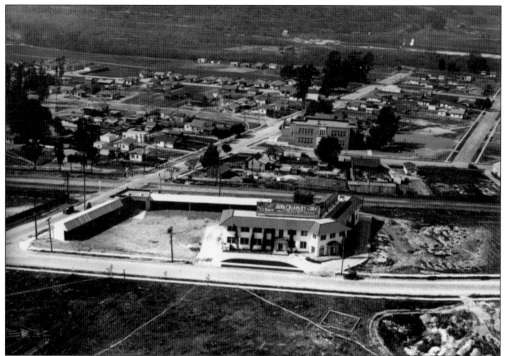

This is a 1925 view of a sparsely populated north Atwater. Chevy Chase Drive crosses the railroad tracks going almost all the way down to the Los Angeles River with Griffith Park in the background. Chevy Chase Grammar School is the two-story brick building on the right, presently the site of the recreation center. On the Glendale side of the tracks sits the Burr Creamery, which later became the Arden Dairy. (Courtesy Los Angeles Public Library.)

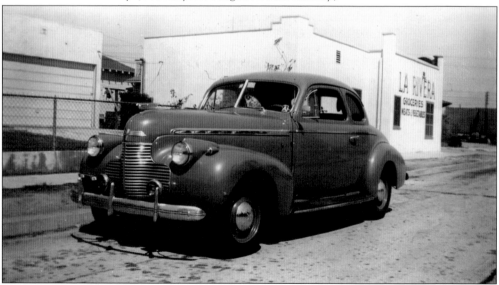

Joe and Nellie Sepulveda's 1940 Chevy sits on Baywood Street close to their home. The north Atwater neighborhood market, La Rivera, sits on the corner of Alger and Baywood Streets and advertises groceries, meats, and vegetables. The market is now a private residence. (Courtesy Larry Sepulveda.)

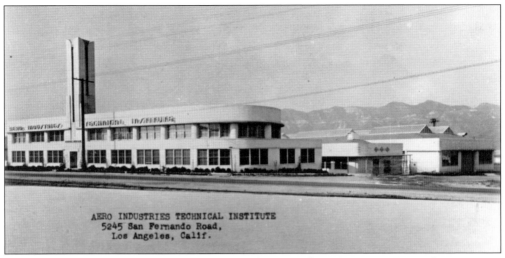

AERO INDUSTRIES TECHNICAL INSTITUTE
5245 San Fernando Road,
Los Angeles, Calif.

The most northern portion of Atwater Village, from Goodwin Avenue to Doran Street, is now industrial, but from the early 1900s, the area was open land. In 1919, Roger Jessup (Los Angeles County supervisor from 1932 to 1946) founded a family dairy business at 5431 San Fernando Road. On its 23 acres along the Los Angeles River, the family raised Guernsey and Holstein cows until 1963. This postcard shows Aero Industries Technical Institute, built in the 1930s, nearby at 5245 San Fernando Road. Mike Carone, an Atwater resident from 1928 to the late 1940s, attended Aero Industries Technical Institute and graduated as a master aircraft mechanic on July 28, 1939. The school trained students for jobs in the aircraft industries for Lockheed, Northrop, and Douglas Aircraft Company. Carone attended John Marshall High School before attending Aero Tech and remains an active alumnus of his alma mater. (Both, courtesy Mike Carone.)

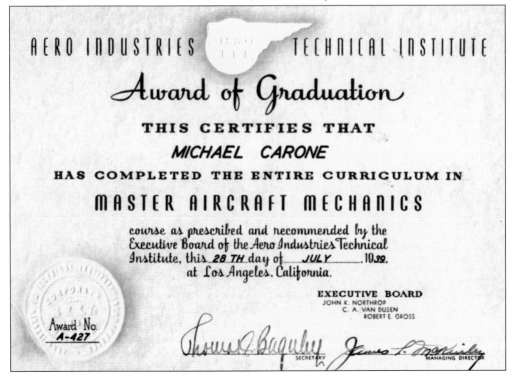

Atwater Village Chamber of Commerce welcomes Los Angeles City Councilmember John Ferraro (center) to Atwater Village at a reception held at the Coral Reef. Also in the photograph are chamber president Gerald "Red" Meade (right) and chamber vice president Bill Hart (left), presenting Ferraro with the key to the village. Incorporated on March 20, 1947, the Atwater Village Chamber of Commerce is one of the oldest community groups in Atwater Village still in existence. (Courtesy Atwater Village Chamber of Commerce.)

Atwater Village Chamber of Commerce members, Los Angeles City Councilmember John Ferraro (second from left), and local merchants are pictured at the installation of the Atwater Village sign on Glendale Boulevard. (Courtesy Atwater Village Chamber of Commerce.)

Seven

SADDLE UP WITH THE EQUESTRIAN COMMUNITY

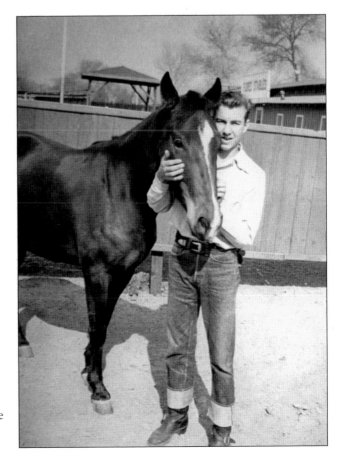

A young rider poses with one of his favorite mounts, Dusty, at Los Flores Stables. Its proximity to Griffith Park and its miles of riding trails make Atwater a perfect location for those who want to ride and still remain within the city limits. Atwater Village is one of the few communities within the city of Los Angeles to have an area zoned for equestrians, including the Los Angeles Police Mounted Unit. (Courtesy LFIA Historic Committee Archives.)

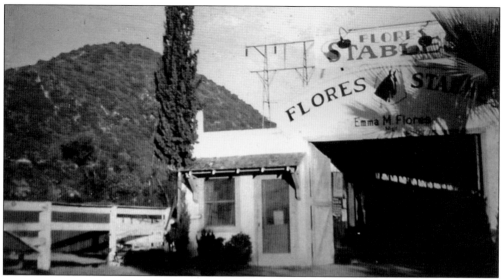

Standing in the shadow of Griffith Park, Los Flores Stables was located on Los Feliz Boulevard and Glenfeliz Boulevard until the Rancho Los Feliz Apartments were built in the 1970s. There are still many stables located in the area that let riders enjoy the scenic trails in the park, as well as the opportunity to ride along the banks of the Los Angeles River. (Courtesy LFIA Historic Committee Archives.)

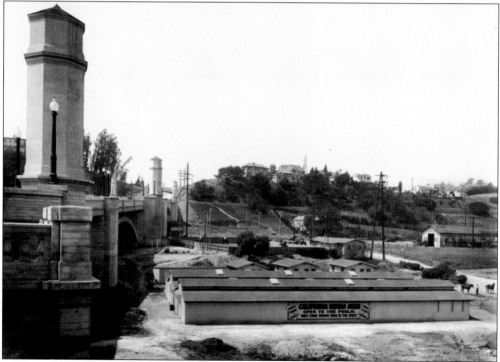

The California Stables are seen in the 1930s alongside the Hyperion Bridge with a dry Los Angeles River bed in the foreground. Next to the riding ring is the Crosetti dairy, and across the street is the Crosetti family home. The houses on top of the hill still remain today. The Interstate 5 Freeway now runs through the area where the stables once stood. (Courtesy Los Angeles Public Library.)

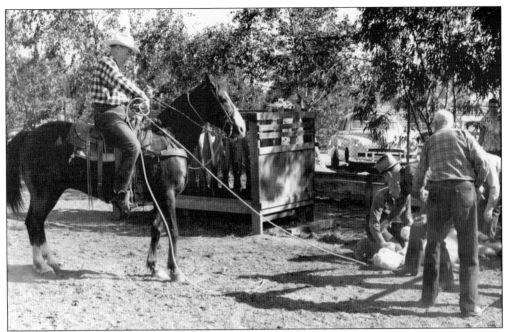

Cowboys are at work on the Pitchfork Ranch in Atwater in the 1940s. J. Marion Wright, owner of the ranch from the 1930s until his death in the 1970s, ran cattle on his "in town" ranch along the banks of the Los Angeles River. He built the adobe house on the property in the late 1940s. This property is now a part of the Paddock Riding Club. (Courtesy Paddock Riding Club.)

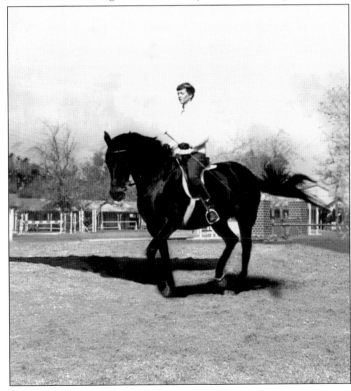

Jane McLoud is riding her nine-year-old thoroughbred mare, Field Mouse. McLoud, a hunter trainer since 1958, took dressage lessons to help in her training. McLoud is putting Field Mouse through a dressage routine and is pictured performing a *piaffe*. McLoud joined the working ranch owned by the Wright family in 1972 and can still be found training at the Paddock Riding Club. The first barn (left) shown in the background remains on the property today. (Courtesy Jane McLoud.)

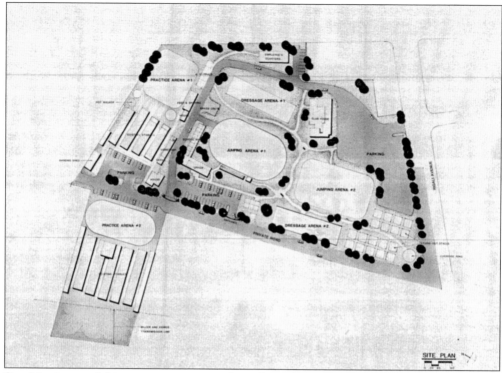

Sam Manis owned this equestrian property from the early 1970s until he sold it to Dave Schmutz in 1986. Schmutz commissioned these plans from architects Gin Wong and Associates in the late 1980s. The design sets out the dressage, jumping, and practice arenas as well as the barns and parking areas for the property. Schmutz ran the Paddock Riding Club as a business for 20 years before selling it in 2006. (Courtesy Paddock Riding Club.)

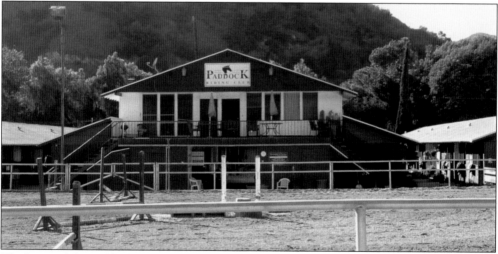

The barns of the Paddock Riding Club are home to independent professional horse trainers who specialize in hunting and jumping, dressage, Western, and more. One of the facility's residents is Enterprise Farms, owned by Jean Gilbert, home of the rare Caspian horse. The facility includes several all-weather arenas and boarding facilities within the city of Los Angeles in north Atwater. (Courtesy Paddock Riding Club.)

This view was taken looking north along the Los Angeles River. Walking or riding along the east embankment of the river, one will pass the Los Feliz Golf Course, the stables of the Los Angeles Police Mounted Unit, the Saddle and Sirloin Club, the Paddock Riding Club, Taking the Reins, and the San Rafael Hunt Club and Stables. Griffith Park lies just across the Los Angeles River, making riding trails accessible to the equestrian community. (Courtesy Los Angeles Public Library.)

The San Rafael Hunt Club and Stables has a long history in north Atwater's horse community. Originally located on Veselich Avenue, owner Elaine Brock moved the club to a nearby location in the 1970s, leasing land in the upper area of what is now the Paddock Riding Club facility. The club now makes its home at 4012 Verdant Street. The stables include boarding facilities, a riding ring, and a jumping ring. (Courtesy Sandra Caravella.)

The Los Angeles Police Mounted Unit makes its home in north Atwater Village, adjacent to the Los Angeles River across from Griffith Park. The facility is on a two-acre piece of land purchased in 1987 by the Ahmanson Foundation and leased to the unit for $1 per year. From the formation of the unit in 1981 until 1987, when the unit became a component of the Metropolitan Division, all officers volunteered, providing their own horses, tack, training, and transportation. The Ahmanson Equestrian Facility consists of a 40-horse barn, offices, lockers, hot walker, riding ring, and all necessary training equipment. There are currently 24 quarter horses that perform the duties of crowd control, crime suppression, and search and rescue. Pictured above is a restored paddy wagon from 1908. (Both, courtesy Netty Carr.)

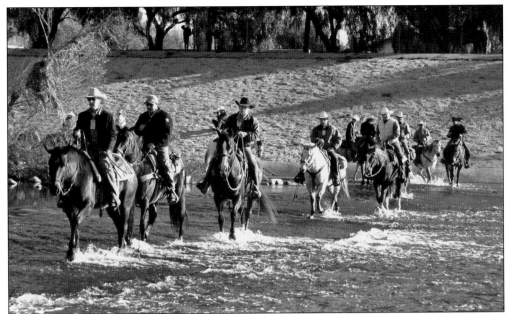

A posse of riders crosses the Los Angeles River. Unfortunately, there is no equestrian bridge in Atwater Village connecting riders to Griffith Park. The horses and riders must cross the river at their own risk. From there, they go up the embankment and through a tunnel under the Interstate 5 Freeway to the trails in Griffith Park. (Courtesy Los Angeles City Councilmember Tom La Bonge.)

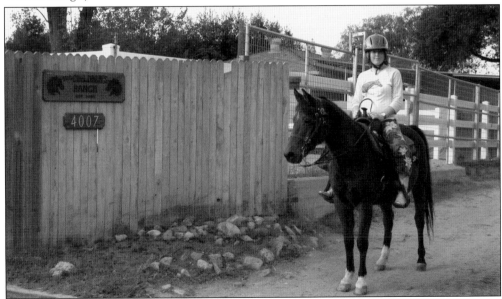

The Children's Ranch Foundation offers therapeutic equestrian programs to children and teens with special needs. Pictured here is therapeutic rider Addie Dector on Storm. Inspired by the positive effect that horseback riding had on her daughter with epilepsy and related learning disabilities, Jackie Sloan, the foundation's director, and her family made it their mission to bring therapeutic equestrian programs to children of all abilities right in the heart of Atwater Village. (Courtesy Jackie Sloan.)

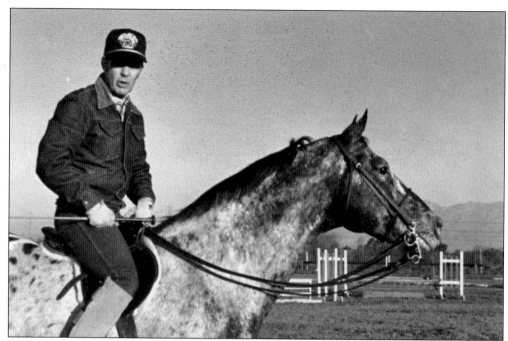

Dr. Walter de la Brosse rides an Appaloosa stallion named Raven's Banner around 1976 at the Michel Manesco Stables (where the LAPD Mounted Unit now resides). De la Brosse retired after 29 years as an animal husbandry professor at College of the Canyons. His current horse is an Appaloosa stallion and son of Raven's Banner named Mr. Lucifer, which he boards at San Rafael Stables. (Courtesy Walter de la Brosse.)

The last of the old wooden barns alongside the Los Angeles River in Atwater is now home to Taking the Reins, a nonprofit organization that teaches life skills to teen girls through the care and riding of horses. In 2008, Taking the Reins purchased River Ridge Stables from the Bonino family. The former white barn was painted red and yellow. The back portion of the property is now an organic garden. (Courtesy Taking the Reins.)

Eight

CREATIVE LOCALS

The Beastie Boys had their studio in Atwater Village in the 1990s. It was called G-Son ("Gilson" with missing letters) after a sign at 3218 1/2 Glendale Boulevard. Atwater has been and remains a neighborhood that artists of all types call home. Today, many residents of Atwater Village work in the entertainment industry, as they have since Walt Disney Studios was located just over the Hyperion Bridge in the 1930s. (Courtesy Ari Marcopoulos, thanks to Danny Jung of the Beastie Museum.)

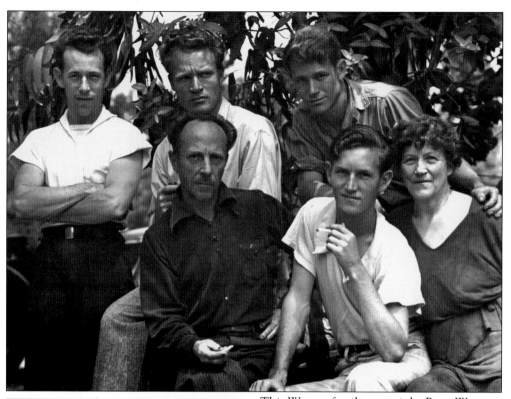

This Weston family portrait by Brett Weston is dated 1935. Famed photographer Edward Weston settled in Tropico in 1909 and married Flora Chandler, a local schoolteacher. He opened his first photography studio in Tropico in 1911. Their house was on a parcel of land surrounded by trees on Perlita Avenue and Verdant Street where their four sons were born: Edward Chandler, Theodore Brett, Neil Laurence, and Cole. Brett and Cole would go on to become renowned photographers themselves. (Courtesy © Brett Weston Archives, www.brettwestonarchives.com.)

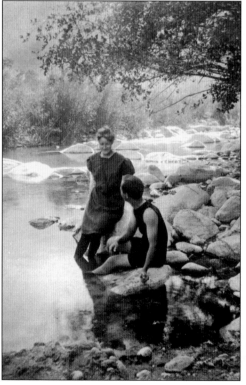

This 1909 untitled Edward Weston photograph is from his collection and is believed to have been taken at the Los Angeles River. The couple in the photograph resembles, and may very well be, Edward and his wife, Flora. Weston did not drive, and many of his early works were shot in and around Tropico. The Los Angeles River was a short walk from their home and his first studio. (Courtesy Center of Creative Photography © 1981 Arizona Board of Regents.)

In this 1942 Edward Weston photograph, Peter Krasnow stands next to the redwood cabin and studio that he built on the 4200 block of Perlita Avenue in what was then Tropico and is now north Atwater Village. He and his wife, writer and poet Rose Bloom, bought the property from friend and local artist and photographer Edward Weston and his wife, Flora Chandler. The Krasnows and Westons lived across the street from each other and were members of a group that worked to establish a community of California avant-garde artists. (Courtesy Center of Creative Photography © 1981 Arizona Board of Regents.)

This oil on canvas of Edward Weston from 1925 was painted by Peter Krasnow, a Russian-born painter and sculptor who came to the Los Angeles area in 1922. He and famed photographer Weston were close friends and neighbors. From 1935 to 1940, Krasnow focused on carved wood sculptures that celebrated the natural beauty of the wood, sometimes using trees from his property or the nearby area. (Courtesy National Portrait Gallery Smithsonian Institution.)

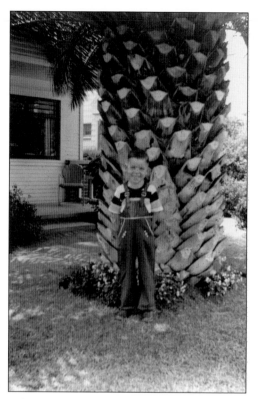

Portrait artist Don Bachardy is shown in this 1940 photograph. Six-year-old Bachardy is standing by a large palm tree in front of his house at 3362 Casitas Avenue. He attended Atwater Avenue, Irving Junior High, and John Marshall High schools. At an early age, Bachardy became a movie buff through his mother's love of the theater. He remembers that the opening movie at the Atwater Theater was *Typhoon* with Dorothy Lamour and Robert Preston. (Courtesy Don Bachardy.)

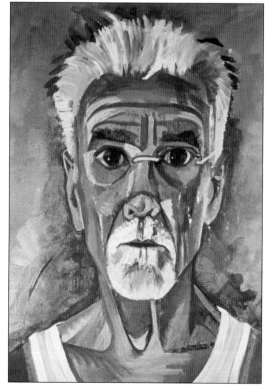

This self-portrait of Don Bachardy was made in August 2010. Bachardy left Atwater in the 1950s and attended Chouinard Art Institute in Los Angeles and the Slade School of Art in London. He settled in Santa Monica with his life partner, Christopher Isherwood, an English-American novelist. One of Bachardy's most notable portraits is the official gubernatorial portrait of Gov. Jerry Brown that hangs in the California State Capital Museum. (Courtesy Don Bachardy.)

From left to right, actor Guy Williams, dressed for his role as television's Zorro; Lawrence Frank, Tam O'Shanter Inn owner; constable Willie Merrilees, dressed in a kilt; and Walt Disney are pictured at the Tam O'Shanter Inn, a favorite local gathering spot for employees of nearby studios. Griffith Park was used constantly as a location for filming, with cast and crew dining daily at the Tam. Disney even had his own table there. (Courtesy Lawry's Restaurants, Inc.)

Actor Jimmy Hawkins, a lifelong Atwater Village resident, started his acting career as a child; he played the role of Tommy in the 1946 movie *It's a Wonderful Life* with Jimmy Stewart and Donna Reed. He also starred as Tagg in the television series *Annie Oakley* in the 1950s. Hawkins costarred in two MGM movies with Elvis Presley in the 1960s. Hawkins, right, and Presley are relaxing on the set of *Girl Happy* in 1965. (Courtesy Bette and Jimmy Hawkins.)

Artist Rafael Escamilla poses in front of his mural depicting a Pacific Electric Red Car as it crosses over the Los Angeles River. Escamilla was born in El Salvador in 1955 and studied architectural drawing at the National University in San Salvador. The tropical colors of his homeland are evident in his works. Escamilla has created several murals in Atwater Village over the last 15 years, many telling its local history. (Courtesy Luis Lopez.)

Local artist and lifelong Atwater resident Tom Hines, right, and artist Rafael Escamilla are "seated" on a bench at a corner bus stop. Hines and Escamilla have worked together on many mural projects. Hines is a painter and sculptor and enjoys working with the neighborhood, sharing his love for community through his art. This mural is at Vince's Market on the corner of Silver Lake Boulevard and Atwater Avenue and depicts the store in the 1940s and 1950s. (Courtesy Sandra Caravella.)

Nine

JUST BEYOND OUR BORDERS

Eight-year-old Don Bachardy and his mother, Glade, sit in front of the Griffith Park Tennis Courts on Riverside Drive. The multi-resource portion of the park offered many activities for local families. The park could be accessed from Atwater by walking over the Sunnynook Bridge, which straddles the Los Angeles River and leads to the tennis courts and municipal plunge area of Griffith Park. (Courtesy Don Bachardy.)

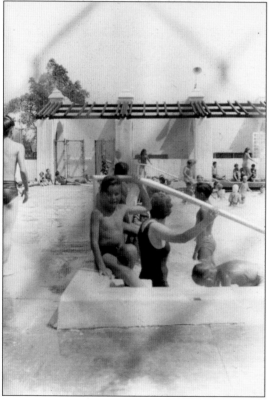

The Griffith Park swimming pool was built in 1927. The Spanish Colonial Revival municipal plunge buildings housed dressing rooms, showers, restrooms, and lockers. Swimmers checking in at the pool were given a locker key on a large safety pin they attached to their swimsuit while they swam. There was also a shallow pool of disinfectant that all swimmers had to walk through before entering the water. (Courtesy Los Angeles Public Library.)

Atwater residents made good use of the Griffith Plunge. Here, Ted Bachardy sits on the edge of the pool in the 1940s. His mom, Glade, cools off while watching kids splash in the water. Towels were not allowed in the pool area, but that didn't stop kids from lying out on the cement deck surrounding the pool to rest. (Courtesy Don Bachardy.)

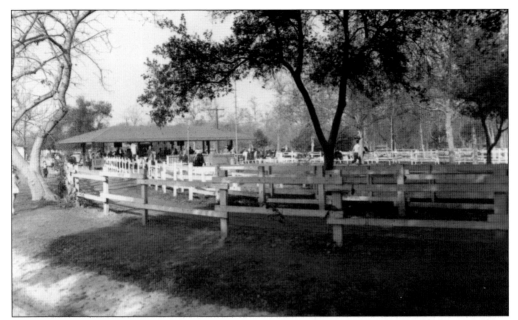

Griffith Park Pony Rides opened in 1948. Los Angeles families have made the rides their weekend destination over the last six decades. Babies start with laps around a fixed carousel called the pony sweep, and through the years they work their way up to the fast-trot ponies on the outer ring. If the children do not like the ponies, there is always the nearby miniature train ride. (Courtesy Los Angeles Public Library.)

A 1956 Chevy is parked in front of the Griffith Park Merry Round with Atwater resident Prisilla Peraza and a friend hanging out the window. The carousel was brought to Griffith Park in 1937 and boasts 68 jumping horses with a band organ that plays more than 1,500 selections of marches and waltzes while the riders spin 'round and 'round. (Courtesy Nancy Peraza Franco.)

The William Mulholland Memorial Fountain, pictured in 1940, is located on the corner of Riverside Drive and Los Feliz Boulevard. Mulholland was a poor Irish immigrant who lived, at one time, on the property. Described as a self-taught engineer, he was instrumental in bringing water to the city of Los Angeles from the Owens Valley. The fountain is often referred to as "the Kool-Aid Fountain" for its changing colored lights. (Courtesy Los Angeles Public Library.)

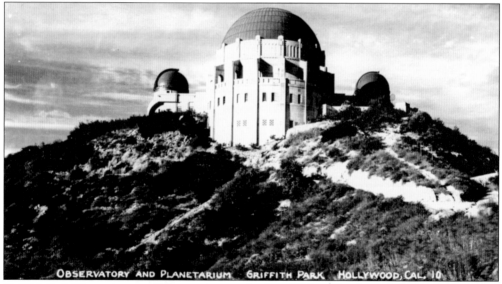

Griffith Park Observatory and Planetarium was built in 1935 and has been designated as Historic Cultural Monument No. 168. The observatory is located on the southern slope of Mount Hollywood at 1,134 feet above sea level, overlooking 4,418 acres of Griffith Park. Atwater Villagers living in south Atwater love the wonderful view of this iconic building, as Griffith Park lies just across the Los Angeles River. This is a postcard dated 1952 to a Miss Chambers from her friend Martha. (Courtesy Sandra Caravella.)

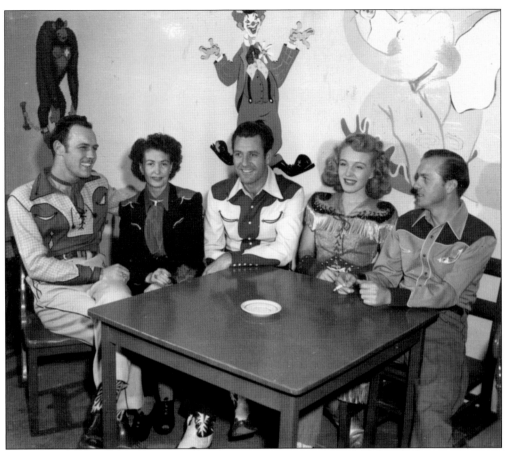

Many television and recording stars entertained fans at the Riverside Rancho in the 1940s and 1950s. Atwater resident Tommie Hawkins was the personal manager for Native American movie and television star Iron Eyes Cody (not pictured), Hank Penny (left), and Doye O'Dell (center). The others in the photograph are Shari Penny (second from left), Carolina Cotton, and a friend. Located at 3213 Riverside Drive, the Riverside Rancho was like a little Grand Ole Opry. The advertisement at right is from the Glendale and Vicinity ABC Directory of 1945. (Above, courtesy Bette and Jimmy Hawkins; right, courtesy Danny Munoz and David Hiovich Archives.)

GLENDALE AND VICINITY A. B. C. DIRECTORY

RIVERSIDE RANCHO
3213 Riverside Dr., Los Angeles 27

GAY 90'S DINING ROOM
OPEN FROM 6 P.M.

The Finest in Dance Music

Chicken

Steak

Spaghetti

★ *Desert Room Cocktail Lounge*
★ *Saddle Room Cocktail Lounge*

THE RIVERSIDE RANCHO
IS ALSO AVAILABLE FOR PRIVATE
DINNERS, DANCES AND BUSINESS MEETINGS

Phone
OLympia
1916

123

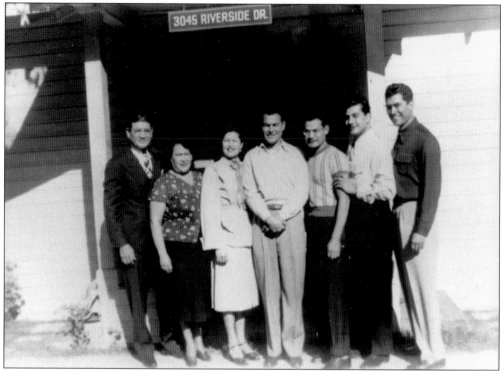

The Manuel Regalado family proudly poses in front of their home at 3045 Riverside Drive in 1949. From left to right, are Manuel, Maria, Nellie, Greg, Ernie, Sal "Chibs," and Rudy. Below, their house is shown to the right of the Hyperion Bridge. On the opposite side of the bridge was where the short-lived (1950–1956) Los Feliz Doubled Screen Drive-in Theater once stood. The Regalado family home and the drive-in theater were both victims of the Interstate 5 Freeway construction. (Courtesy Larry Sepulveda.)

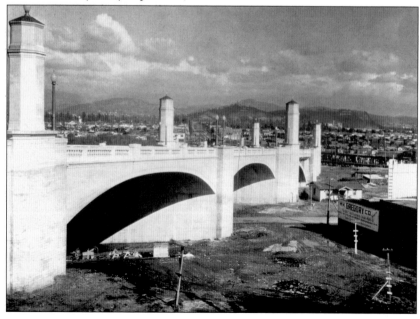

A very large ice cream cone sign and the Pacific Electric viaduct mark the intersection of Fletcher and Riverside Drives in the 1940s. A trip to Currie's Ice Cream Parlor, home of the Mile High Cone, was always fun and delicious. On the hill right behind Currie's are the steep steps that lead to the Red Car stop platform. Although the Pacific Electric Fletcher Drive viaduct and the trolleys are long gone, the steps and landing can still be seen above the Home Restaurant, which now occupies the old Currie's building. (Courtesy Pacific Electric Railway Historical Society.)

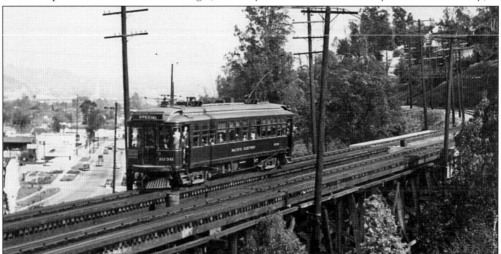

Pacific Electric Railway Interurban No. 1036 crosses over the Fletcher Drive Bridge headed into Atwater Village in the 1940s. The Pacific Electric traveled from downtown Los Angeles through Edendale, crossing Fletcher Drive and then passing over the bridge that crossed the Los Angeles River and on to Glendale Boulevard, making stops in Atwater before going to Glendale. This trolley is about to pass over Currie's Ice Cream—the ice cream cone sign can be seen at the left. (Courtesy Pacific Electric Railway Historical Society.)

2934 Riverside Drive, Los Angeles 26, Cal.
(One Block East of Griffith Park)

The River Glen Motor Hotel stood at 2934 Riverside Drive. It advertised 22 new units with wall-to-wall carpet and full-tile showers, Panel Ray heaters, radio, and garages in an insulated, elegantly furnished, roomy motor hotel just eight to 10 minutes from Hollywood or downtown Los Angeles. The River Glen was used as a location in the filming of *Pulp Fiction*. Butch (Bruce Willis) and Fabienne (Maria de Medeiros) used it as their hideout. The hotel was demolished in the late 1990s, and this is now the site for Taylor Brothers Architectural Products. The photograph below shows the same location in the 1920s at the corner of Riverside Drive and Glendale Boulevard. The River Glen Motor Hotel stood approximately where the CalPet Restaurant is shown in this picture. Also visible is the wooden trolley trestle over the dry Los Angeles River bed and portions of south Atwater. (Both, courtesy Los Angeles Public Library.)

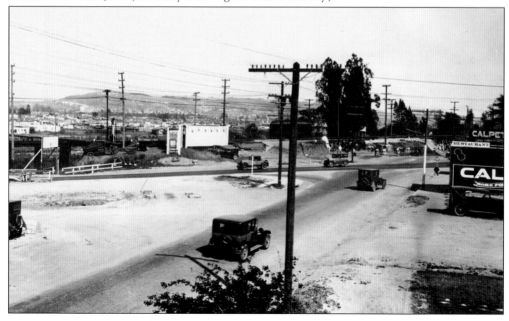

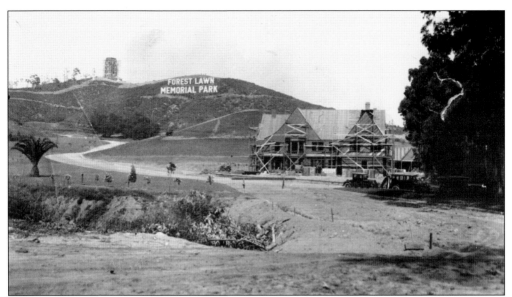

Forest Lawn Memorial Park was founded in 1906 in Tropico, California, now south Glendale. Development of its 55 acres would become the vision of Dr. Hubert Eaton, who came to the cemetery in 1912. He was new to the business and found it dreary and depressing, with no comfort for the living. Eaton developed a concept of what he thought a cemetery should be—a place of sweeping beauty and rolling hillsides framed by evergreen trees with the addition of classic art and architecture, all within a beautiful park setting. Residents of the surrounding communities have Eaton to thank for the view they enjoy of the green, rolling, tree-topped hillsides. Shown above is the administration building around 1924. Pictured below is the Hall of the Crucifixion-Resurrection, which houses the 195-by-45-foot painting *The Crucifixion* by Jan Styka and *The Resurrection* by Robert Clark. The building was dedicated in 1951. (Both, courtesy Forest Lawn Memorial Park.)

www.arcadiapublishing.com

MAP SEARCH

Discover books about the town where you grew up, the cities where your friends and families live, the town where your parents met, or even that retirement spot you've been dreaming about. Our Web site provides history lovers with exclusive deals, advanced notification about new titles, e-mail alerts of author events, and much more.

MADE IN THE USA

Arcadia Publishing, the leading local history publisher in the United States, is committed to making history accessible and meaningful through publishing books that celebrate and preserve the heritage of America's people and places. Consistent with our mission to preserve history on a local level, this book was printed in South Carolina on American-made paper and manufactured entirely in the United States.

This book carries the accredited Forest Stewardship Council (FSC) label and is printed on 100 percent FSC-certified paper. Products carrying the FSC label are independently certified to assure consumers that they come from forests that are managed to meet the social, economic, and ecological needs of present and future generations.

FSC
Mixed Sources
Product group from well-managed
forests and other controlled sources

Cert no. SW-COC-001530
www.fsc.org
© 1996 Forest Stewardship Council

Find Your Place in History.